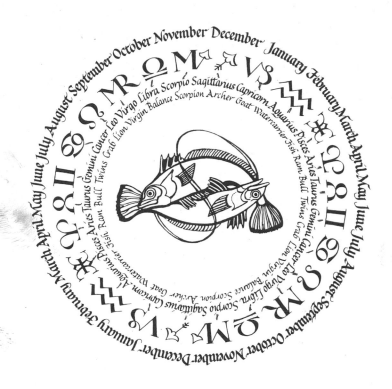

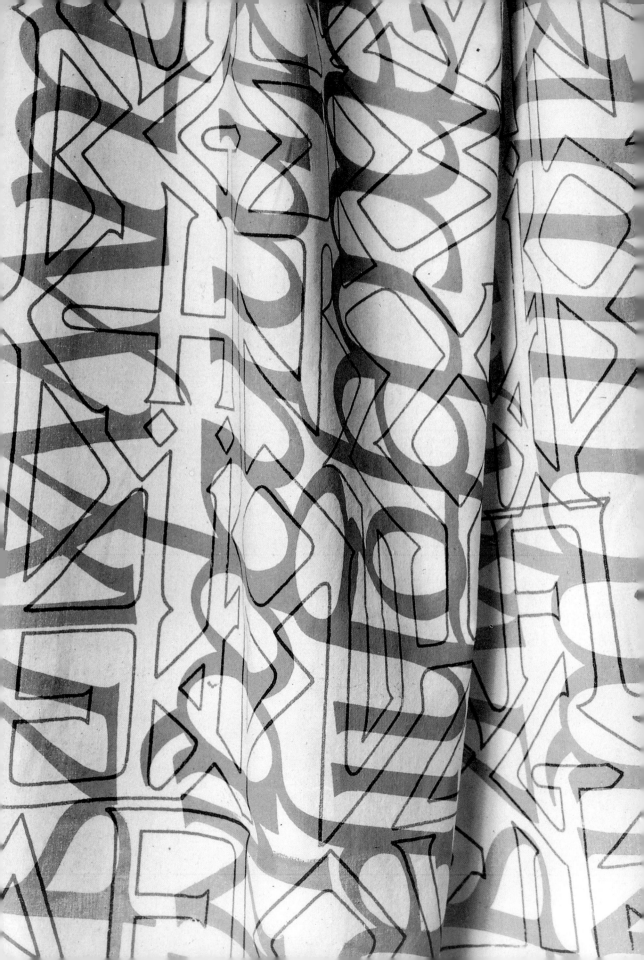

ROSEMARY SASSOON

The Practical Guide to

LETTERING

&Applied Calligraphy

with 225 illustrations

THAMES AND HUDSON

*Half title: Zodiac tablemat
design by the author, with a
lino cut by Pat Savage.
Frontispiece: printed curtain
material from a design by David
Kindersley. (see page 106)*

First published in Great Britain in 1985
Reprinted 1987

Printed and bound in the German Democratic Republic

Contents

Preface

THIS BOOK IS ABOUT LETTERS – letters made with different tools in different materials.
It is intended as an aid to teaching and is divided into three stages. It spans the gaps between beginner, serious student and professional, so that students working on their own can follow it as a complete course, or teachers can use it at any level.

First there is a series of informal exercises to show beginners, or those who have kept only to the broad-edged nib, how to build up their knowledge of letterforms. When I use these exercises with my own students I do not provide a model, just an explanation of what is needed; the point of this is to encourage individuality. In this book, however, a beginner, an intermediate and then a professional, each in turn, provides demonstrations showing that the principles behind the exercises are relevant and produce original letters whatever your level.

Beginners are soon introduced to drawn Roman capitals and then to the idea of three-dimensional letters. First there are simple methods and then increasingly skilled techniques to practise. The need for a balance between discipline and creativity is stressed throughout the book.

The work illustrated in the second section shows that there are many routes to professionalism. Reading about the different approaches to training, you cannot escape the fact that it is hard work to get to the top, whichever way you choose, or whichever medium you decide to work in.

The third and largest section of the book concerns the work of professionals specializing in various aspects of lettering. However advanced you may be, you can get new ideas here and compare techniques, but this part can be used in other ways as well. It could be a career guide for aspiring letterers, showing calligraphers how to put their skill to further practical use. In addition, craftsmen already experienced in working with stone, glass or wood, but who have not used letters before, can see the stages that have to be mastered.

Collecting material for this book and talking to my colleagues about their work has been not only a great pleasure for me, but an education as well. The lettering community is a close-knit, friendly group, and craftsmen are traditionally generous about sharing their knowledge and skills. Even so, the generosity and encouragement I have encountered have been incredible. Most of us had the privilege of learning, at some time, from one or more of the great lettering masters, and feel it almost a duty to hand on what we were taught.

It is asking a lot of top professionals to hunt in their files, and sometimes even in their wastepaper baskets, for discarded sketches. But these rough sketches, along with their working drawings, are immensely important, for they show so clearly how different craftsmen plan their work and adapt their letters to suit both the tool and the material.

It is not easy to draw a line between calligraphy and lettering. Two different words are used today to describe a handwritten document and a stone inscription, where once the word 'lettering' was used for both. Where should the change occur? Between pen-written letters and drawn Roman capitals, perhaps? Then what are versals or brush letters? Does it really matter? It only matters because the word calligraphy seems to have been adopted for pen letters only. This is proving divisive where there should be no division. It has resulted in calligraphers ignoring, to their cost, the functional aspect of lettering and the skills of drawn and cut letters.

Most of the craftsmen whose work appears in this book began lettering with a broad-edged pen. Their work shows what they owe to their early training. I hope this will tempt students and calligraphers to branch out in new directions. It should also give both practical help and inspiration to those who want to accept the challenge of working with letters.

Part one
Breaking away from the pen

THIS PART OF THE BOOK is a beginning for some but a bridge for others. For those who have mastered the pen, it is a bridge to the wider world of drawn and three-dimensional letters.

The pen gives a much needed early discipline, but one can easily become too dependent on it. When you learn to keep your pen at a constant angle, it sorts out all your thick and thin strokes for you. Eventually you may become dissatisfied with its limitations, but find it difficult to take the next step, which is learning to draw both sides of each stroke. This gives you more freedom but less help from the pencil or whichever other tool you decide to use. You must learn to temper this freedom with discipline and put it to work to your own advantage. Keep the best that the pen has taught you and learn to build on it.

A serious letterer needs a mixture of control and relaxation. The controlled, disciplined part is obvious. The relaxation allows individuality to express itself through the traditional letterforms. So think of your training as a judicious mixture of these two elements.

The introductory exercises encourage spontaneous lettering, and are meant to be fun. They show how to play with letters and introduce the idea of a personal movement. They also encourage those who have previously let the pen do most of the work, to start thinking about solid letters. Different proportions and stresses give the familiar shapes a new look.

As for discipline, the time-honoured method of learning lettering was to copy casts of original Roman inscriptions. In recent years, however, it has been felt that too much discipline stifles creativity, and that this method is too repressive. It was therefore banished from most art schools, along with drawing from the antique. But you still need to study these classical forms, as they provide the basis of our alphabet. It does not much matter whether you copy from the original second-century incised letters on the base of Trajan's Column in Rome or from one of the many later alphabets derived from them. If you cannot find

anything else to begin with, a good book of classic type faces is not a bad starting-point.

In this section there is a simplified method of learning to draw Roman capitals. It shows you how to build on a skeleton made with a broad-edged carpenter's pencil. Then you are encouraged to think of Roman capitals as they were first used: as incised letters.

Letterers need a repertoire of historical letterforms, both written and incised. These will not necessarily be copied exactly but used as a basis for creativity.

Experienced letterers do much of their working-out in their head. As you progress from the experimental stages, you need enough of a background to help you conjure up an image of the letter you are aiming at before you can explore and refine it on paper.

The different approaches to designing letters for cutting are explained and illustrated by beginners' work. These personal attitudes are echoed by the professionals. Later on, when you are experienced, there will be a fine balance between how much you draw up your letters before you cut them and how much you leave to the tool. There may be difficulties at first if you lean too far in either direction. You can spot this in some of the students' work. Straight from the mind's eye via the hand and tool to the final material may be what you are aiming at; but that takes a lot of experience.

Repeat patterns (see page 19). Cutting out with a knife.

Beginning again
New tools for freer letters

If you are already equipped as a calligrapher all you may need in the way of tools are a few new brushes and pens.

Pens with a good ink flow are needed for larger, freer lettering. Try automatic pens and coit pens too, both of which have good reservoirs.

Balsa wood makes the most flexible of implements, and produces subtle textures. To make yourself one of these pens all you need is the side of a balsa wood matchbox. If you cannot get one then you can buy the thinnest quality from a model-maker's shop. Trim the balsa wood across the grain with sharp scissors or a knife, then slot it into a suitable stick to make a handle. The only disadvantage of your home-made pen is that it does not carry much ink.

Experiment with fine fibre pointed pens. Some of those now on the market compare favourably with expensive technical drawing instruments.

Do not forget the humble carpenter's pencil. It is always a pleasure to use for roughs, and can produce free finished letters too. Graphite blocks work in the same way. They can be easily carved into any size. You will see how to use these broad edges to construct Roman capitals on page 26. Double pencils are not just a beginner's tool. On page 36 you will see how their double lines form the basis of large drawn letters.

You should not need reminding to keep your pens scrupulously clean, and your points sharpened. A true craftsman can be judged by the condition of his tools.

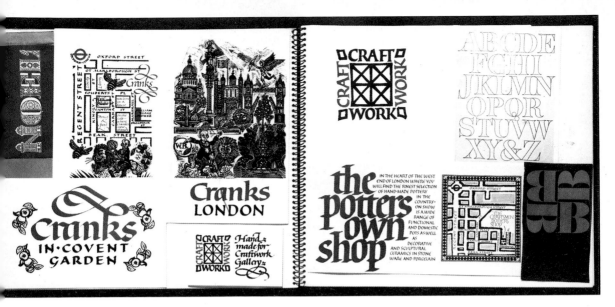

Keeping a scrap book

You will need the stimulus of new ideas, so this is a good time to start keeping a scrap book. Cut out and stick in any interesting lettering or typographical layouts that you may find. Remember that rough scribbles on the back of envelopes may prove as valuable as glossy advertisements.

If you go to classes, always keep the corrections the teacher makes on your work. These will be specially useful as they are relevant to your own letters.

Work on these pages includes lettering for advertising by Donald Jackson, Gaynor Goffe and Charles Pearce, engravings by John Lawrence, an alphabet by David Kindersley and the Barbican logo by Ken Briggs.

Another scrapbook contains typographic examples such as this beautifully designed pamphlet produced by the Monotype Corporation in the 1950s to publicize the typeface *Albertus*, designed by Berthold Wolpe.

You will be surprised how quickly your collection grows. My own scrap-books are now overflowing from their shelf. They make a fascinating and nostalgic record of the changing stages and styles of my lettering career.

Breaking free

Judy's work was captured at the moment when she broke free from conventional letters. Her first layout was good, but she felt frustrated. She was trying to design an informal card with formal, separated capital letters. When she relaxed and let the pen flow more freely she felt better and the design was much more effective. She used some natural joins and free flourishes. Notice the 'R's. They worked out particularly well. She is still keeping the pen at a constant 30° angle. Learning to twist the pen and vary the angle will be her next step.

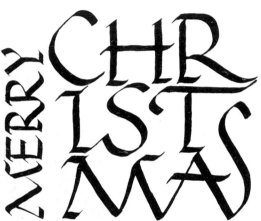

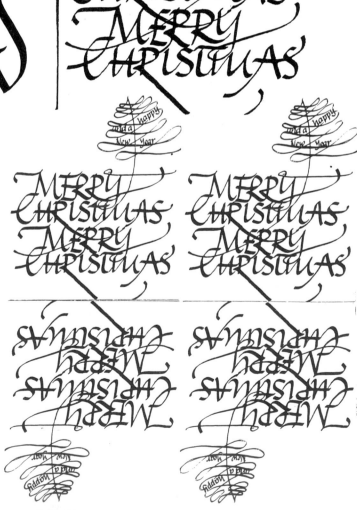

The four copies were just pasted together to speed up the production of Christmas cards. However, they show how almost any lettered words can be used as a repeat pattern. It was a coincidence that these prints ended up facing in different directions. In fact they would make an ideal repeat for a wrapping paper. In all-over packaging design the message needs to read from different angles.

12

This flourished ampersand, by
Briem, illustrates a step-and-
repeat design using a grid
(shown in red).

Repeat patterns

The emphasis of this book is on applied calligraphy. So,
from the start you must begin to think of how you can
use your skills in a practical way. Almost any lettered
motif can be repeated, whether it has been specially
designed for this purpose or not. Look at the examples
on this page. I have chosen simple words or letters
from students' work as they practised the exercises that
appear on the next few pages. The originals have been
reduced and pasted up to show how easy it all is once
you start thinking of your calligraphy as a design.

Modern technology is there to help you. A
photocopying machine enlarges and reduces easily and
cheaply.

Loosening-up exercises

Denys Taipale is a calligrapher from Great Falls, Montana, who spends a great deal of her time lecturing and running workshops throughout the U.S. and Canada. She visited one of my classes and demonstrated these loosening-up exercises to the students.

Try them. Forget discipline and enjoy yourself. You may be surprised at the results even if you are a beginner. Write with anything you like: a broad-edged nib, a calligraphic felt pen, brush pen, fibre tip or even a soft leaded pencil.

Denys says, 'In the beginning when we learn letters we "draw" them, agonizing over each part. However, to achieve the grace and beauty of movement in writing, it is the flow of the hand *during* and *between* letters that is so important. This exercise allows the student to work on that "air movement" with pen on paper.

'Try writing to music, staying with the beat, letting your hand dance freely across the paper.'

Denys' semi-formal flourished capitals.

Write your capital letters at speed. Let them flow freely. Allow pen lifts between letters as desired.

Now go faster and faster with as few pen lifts as possible. This makes an interesting pattern – free and full of movement.

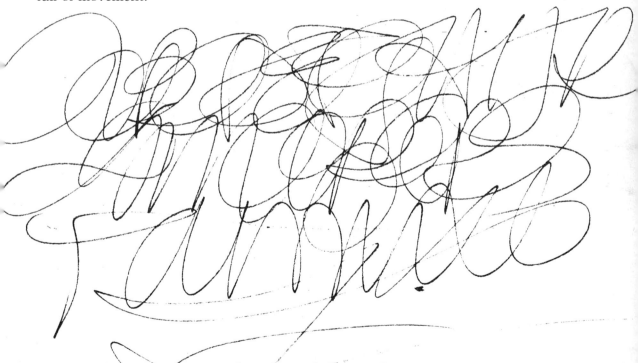

Write them again freely and rapidly with a pointed tip. Do not lift the pen from the paper. The movement of line shows the 'air movement' the pen would have made if it had been lifted from the paper.

Loosening-up On the last page you saw a teacher demonstrating this first exercise. Now you can see calligraphers at different stages of their studies learning from it.

This is what happened when Timothy, who is experienced but still eager to experiment, speeded up his capital letters.

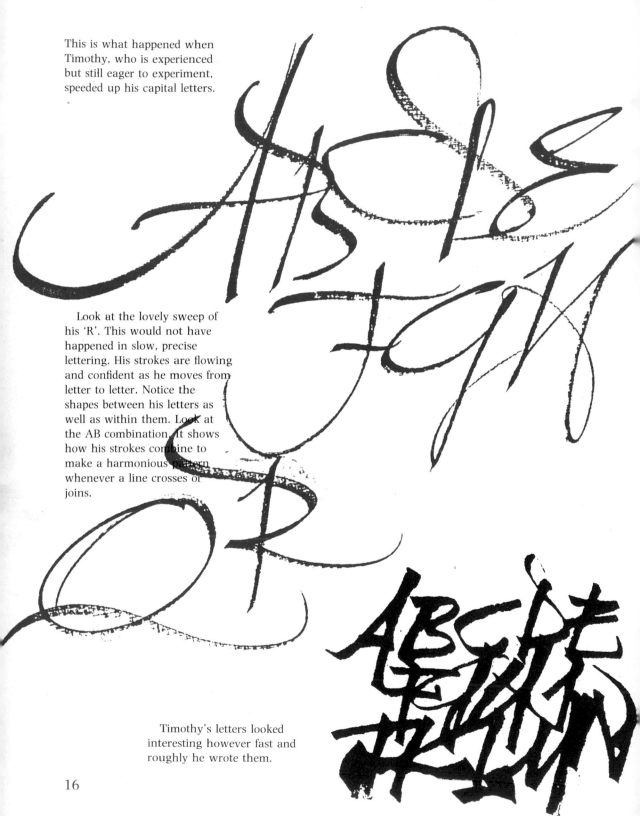

Look at the lovely sweep of his 'R'. This would not have happened in slow, precise lettering. His strokes are flowing and confident as he moves from letter to letter. Notice the shapes between his letters as well as within them. Look at the AB combination. It shows how his strokes combine to make a harmonious pattern whenever a line crosses or joins.

Timothy's letters looked interesting however fast and roughly he wrote them.

16

The work on this page was done by first-year students.

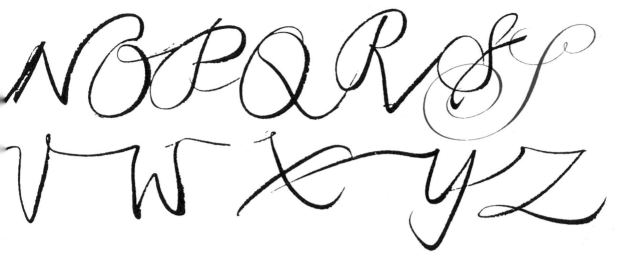

This student (above) showed that she had a natural copperplate movement. She benefitted by discovering that a normally difficult style of calligraphy would come easily to her. The example of a classical copperplate 'S' shows how close she came at her first attempt. The letters came out well on the whole. They certainly 'danced across the page'. Understandably, the movement between letters was less confident than Timothy's and this sometimes resulted in awkward joins such as X–Y and R–S. Some students saw the joins as horizontal and some as rounded movements.

What can these exercises do for you? To profit from them you must learn to look closely into your work. Pick out the interesting personal elements in your relaxed scribbles. Then you can incorporate them as a permanent feature of your letters. This is a good way of introducing individuality into your calligraphy.

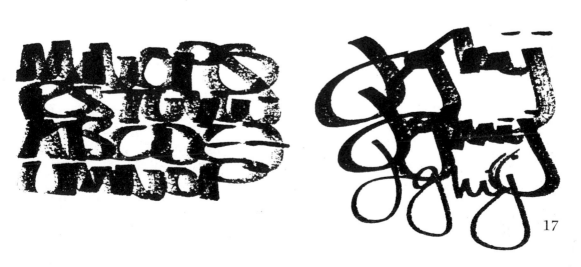

Changing proportions

one two three four five

one two three four five

one two three four five

one two three four five

This exercise is designed to make you flexible about the weight and proportions of your letters. Too many calligraphers are taught that letters should only be between four and five pen-widths high. This may be necessary in reproducing the classical hands exactly, but if you want freer lettering you will profit by taking a more flexible attitude. Change the proportions and you can learn a lot about how letters can change too.

Start with a medium nib. Draw guidelines six pen-widths apart. Then, using the same nib, reduce the space between lines by stages until they are only two pen-widths apart. You will see at once how the letters have become simplified.

Briem demonstrates the exercise above and Timothy below.

tamra

tamra

tamra

tamra

tamra

Timothy's letters changed from being tall and slim with pronounced serifs, to much simpler short fat letters. But they are not any the less attractive. Look closely and you will notice that his 't's become proportionately shorter and the crossbars lower down as his letters become smaller and fatter.

You can give capital letters the same treatment. Start with lines eight or nine pen-widths apart and go down to about four, then see what happens.

Once again Timothy shows how his letters change from being fairly formal, with interesting terminals, to simple shapes with barely a pen lift.

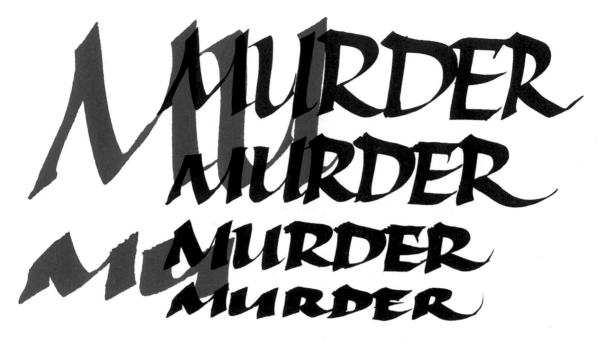

There is another lesson to be learned here. In the early stages students find written capital letters more difficult than small letters, hence they often appear weak and straggly. See how these letters improved as they became firmer and fatter. If you want to write a whole line of capital letters do not make them too tall and thin at first.

A relative beginner can show interesting results too. Look at what happened to the dots over Siobhan's 'i's, and how she dropped her 's's to make enough room for them as they got shorter and fatter. Smaller writing does not always mean that a word will take up less space.

Changing pen-angle

This exercise is meant to show you what happens to letters when you completely change the angle of your nib. The stresses of the strokes alter and you are faced with a new set of design problems.

Just turn your broad edged pen, or calligraphic felt pen, around so that the fattest stroke is the horizontal. Then the upright becomes the hairline. You may not produce beautiful letters to begin with, but trying an unfamiliar pen-angle will certainly make you think about what you are doing.

abcde fghi

Briem demonstrates this above and shows that it is not a new idea. This typeface, Nebiolo (below), designed by Aldo Novarese, has been in use for quite a few years.

abcdefghijklm
ABCDEFGHI

ABUD

Timothy changed the angle of his pen to write these
quick capital letters. They improved as he got used to
the unfamiliar angle.

Lynn is a student who did not particularly enjoy
formal lettering. But she has a good eye for design. She
was sketching a logo for a dance studio, and when she
changed the pen-angle the design gained strength. The
strong horizontals brought the idea to life.

Drawing around letters

This is a difficult exercise, but do try it. It gives you the feel of the shapes and solidity of letter-forms. It will make you think in three dimensions without actually cutting letters.

Briem interprets the exercise with short strokes directed into the outline of the letter which produces a mosaic effect. Ideally he would like to see some colours introduced. Notice that the proportions and quality of his Roman capitals survive even this rough treatment. On page 26 you will find a short cut to learning Roman capitals. But to achieve Briem's standard you will need intensive study of the original cut letters and plenty of practice. Timothy is going through this stage now and is getting good results. Your written capitals would benefit from this as well as your drawn or cut Roman letters.

Timothy cheats a bit by almost outlining his letters before adding the texture. The exercise does you more good if you do not draw your letters first. This is an effective technique, which would do well on a book jacket.

Timothy had a second attempt at this exercise. This time he waded straight in with a broad edge. He found it quite a challenge. It took several tries before he was satisfied with both the letters and the spacing of 'Caroline'.

Capital letters proved a little easier. He found that the outlining could help him judge his spacing.

This beginner was having trouble with her Versals. So she tried drawing in the background first, and produced simple but interesting letters. She went on to design all her Christmas tags this way.

Three-dimensional letters

These pages show different ways in which you can approach simple letter cutting. (1) You can design letters on paper, trying to imagine how they will be cut in whatever material you are going to use. They may not be very practical, if you have not had much experience, but they could look original. (2) You can go to the opposite extreme and cut straight into the material without a preliminary sketch so that the tool alone influences the way the letters turn out. (3) The middle way is to design the letters carefully, transfer them lightly and let the cutting give them their final character.

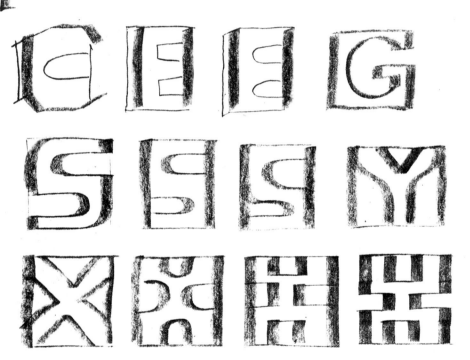

Colin chose the first way. After a quick sketch with a wedge-shaped felt pen he used a carpenter's pencil to design some letters suitable for hallmarks. He cut some of the letters into chunks of chalk from the local hills. (There is no need to use expensive materials to start with.) By the time he got to the end of the alphabet he was becoming much freer. Some of his 'x's would make good lino-cut repeat patterns (see page 13). Gwen chose the second way. Using a sharp blade, she cut her monogram directly into a piece of corrugated cardboard. The letters are effective but simple, as the knife was just allowed to make the straight cuts that are easiest for it.

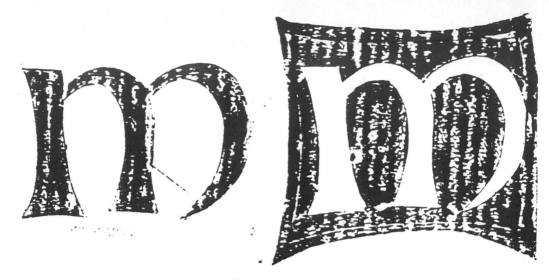

This letter was more carefully designed before being cut into corrugated cardboard. When stuck onto a backing of card, both the positive and the negative 'm's could be printed.

Linocutting is good practice. Both the material and the tools are inexpensive and easily obtainable. Draw a quick sketch and use a grid to enlarge or reduce it if necessary. Then trace it, and do not forget to reverse the design before you tranfer it on to the lino. Use carbon paper for transferring to a light surface or home-made chalk paper for a dark surface. Painting your lino black beforehand helps you to see the effect of your cutting more clearly.

A short cut to Roman letters

Miriam Stribley gives a basic grounding in historic letterforms to students she teaches on two BA graphic design courses. Initially she only has these students for five days, so she has developed a simplified and effective way of teaching Roman capitals.

Any broad edged tool can be used to construct the letters: a carpenter's pencil, a piece of balsa wood or a large nib. The serifs are drawn in afterwards.

MNNM

RSTUV

Holding the implement at 30° gives the correct weight of thick and thin stroke to the classical Roman letters, providing they are drawn 9/10 nib-widths high. Angle 30°, thickness of stroke 1/10 height, Serif 1/4 of circle.

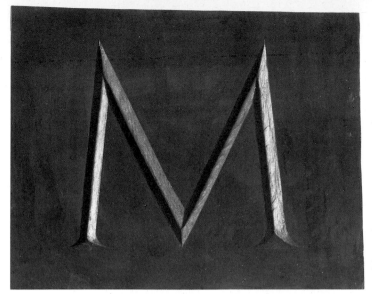

This 'M' was cut into eight or nine layers of card glued together, then painted.
The 'S' was cut into a block of clay with the surface scratched to give a texture and the 'P' and 'B' into a slab of 'cheese-hard' plaster of Paris.

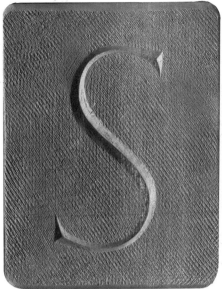

Cut Roman capitals

Miriam believes that it should be understood from the start that Roman letters were essentially three-dimensional. So her students are encouraged to cut a letter in any suitable material they can lay their hands on: soap, balsa wood or even chocolate! They use sharp blades, scalpels or good pen knives, not specialized tools.

Afterwards the students are asked to paint a three-dimensional representation of their letter. All this work on Roman capitals is fitted into one day. The practical assignment is required homework.

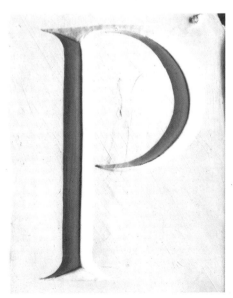
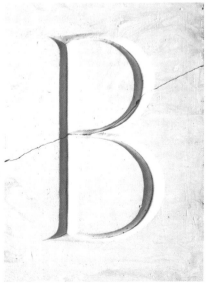

Expressive calligraphy

After their short introduction to the history of the development of letterforms, Miriam Stribley's students are encouraged to experiment more freely. They apply this free calligraphy to book jackets, record covers, posters, etc.

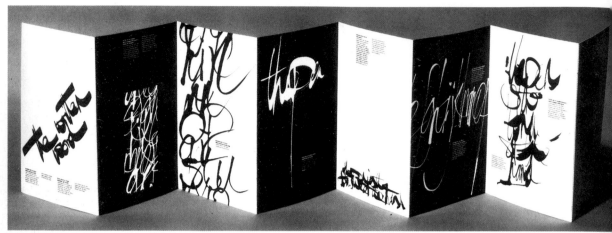

The brief for Stewart Webber's project was to design an exhibition panel containing an aspect or example of the 'Written Word'. The typography is planned in a four-column grid. This complements the informal calligraphy. The alternating black and white panels were all worked black on white, and photographically reversed as required. Part of the alphabet shown on the left, was reversed and used on one of the panels. It is shown here almost full size.

All the work on these two pages was done with automatic pens. You need to work these pens hard until they become pliant.

Miriam herself does a lot of television graphics. This caption is an example of her work. She tried to make the uprights suggest the feel of a bell rope.

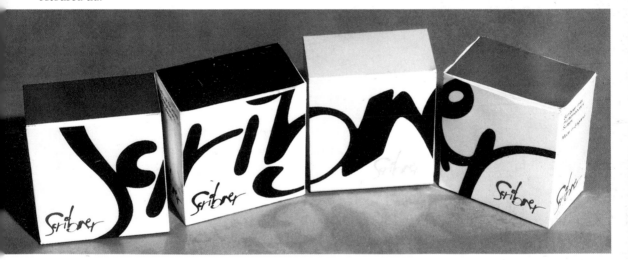

This packaging project by Andrew King is a good example of how to use expressive calligraphy. In the originals each box had a different coloured lid.

It is the tonal quality of Dean Robinson's piece of work that is so intriguing. The original is in shades of blue. 'The moving finger writes . . .'

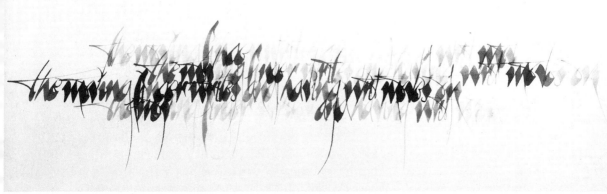

Part two
Halfway there

BY THE TIME this book is published most of the people represented in this second section will be practising as professional letterers. One of them has in fact been doing so for some years, but has kindly lent examples of her early work.

This intermediate work is captured at a decisive moment. It shows some of the decisions that have to be made both about training and about letterforms.

There are a number of ways of reaching professional level and would-be letterers must choose their own route. Their choice can be influenced by the availability of courses or apprenticeships, by economic factors or by personal inclination. Some people may have the self-discipline to work by themselves while others need constant guidance.

At this intermediate stage, you are potentially open to the influences of other people's strongly personal letterforms or techniques; your own teacher's perhaps, or some other past or present master. In this section you can see how some students are set to study well-known letterers' personal styles, and how others have fallen under the spell of one or other of these great masters. This is all to the good, and perhaps a necessary part of development, as long as the skill and knowledge gained are used towards building up your own individuality and techniques.

This part of the book shows how Timothy Donaldson has reached a very high standard entirely on his own. He has never had a formal lettering lesson in his life but has searched out the best books available to guide him. Patrick Knowles, on the other hand, has had a long art-school training. He had a good start to lettering during his three-year graphics course, and was encouraged to carry on for another year and do an MA. Fiona Winkler did a Foundation Course at Art School and was lucky enough to find a craft apprenticeship. She continues with her training in letterforms at evening classes.

Timothy, who already gets plenty of commissions, could do with some constructive criticism and a really good master class. Patrick needs a lot of work experience. Fiona knows just how fortunate she is.

Judith had a later start and took a longer part-time course to fit in with family commitments, while Bettina found a new career and an ideal training quite by accident.

My own training was yet another mixture; two years' full time at art school followed by a studio apprenticeship and three years part time continuing training as a classical scribe. Somehow, between the commercial pressures and the traditional pen-written bias of the calligraphy, a deep study of Roman letters got missed out. My lettering has always suffered as a result, my capital letters most of all.

However much formal training you have had, you will need a different approach when you start in a workshop or studio, where you will have to come to terms with commercial pressures. I am a great believer in not leaving this too late. So, unless you have an outstanding teacher work-based experience can prove just as effective as a lengthy training. In either case it is up to you to be self-critical and not let your standards drop.

A letterer needs determination, discrimination and almost fanatical dedication to the craft to get to the top. Unless you like the challenge of working to a brief it is not much good thinking of a career in any branch of lettering. You need to be a businessman, sometimes an opportunist and certainly an optimist to get through the lean patches.

Use this part of the book to help you think of your training and the approach to professional work. The techniques shown here carry you on to the next stage, and point the way ahead.

Using a balsa-wood pen

Timothy Donaldson

Timothy was cleaning windows when an estate agent asked him to paint a 'For Sale' sign. This was his introduction to lettering, and he soon found that he had a remarkable aptitude for it. One of the most interesting things about Timothy is the way his talent has developed in isolation. His lettering is fresh and consistent as it mostly follows his own natural writing movement. Notice his sweeping 'D's.

Working from the best books he could find, Timothy has of course been exposed to outside influences, perhaps most of all to the work of Herman Zapf. Just recently he has been helped considerably by Briem.

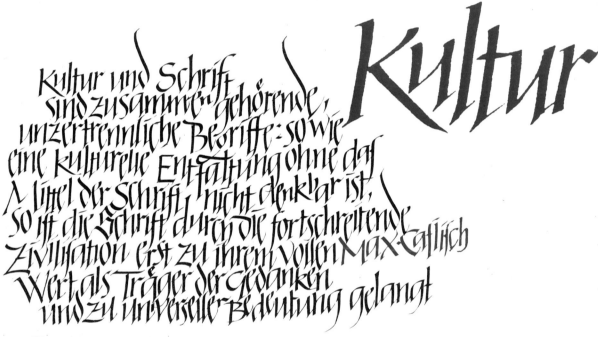

Using a balsa-wood pen

Timothy's enthusiasm is infectious. Whatever implement he picks up he produces something lively. Thin balsa wood makes a flexible writing implement. Timothy shows the texture you can get by writing on a coarse linen-weave paper (opposite). He dashed off the whole alphabet straight away without any planning, so predictably some letters came out better than others. The W X and Y are particularly lovely in their movement. Timothy found that his home-made pen also worked well on canvas. Now he intends to design a calligraphic roller blind for his kitchen.

Cutting letters out of card

This is a very simple technique for anyone to try. Timothy has drawn the letters and then cut them out of thin card with a sharp blade. He says, 'Any technique that makes you cut the letters manually gets you more closely involved with their form.'

He used this method to produce an exhibition piece (detail below), using a thicker card and enhancing the three-dimensional effect by backing the letters with gold foil. It is no good pretending that this is easy!

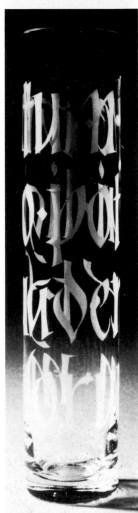

tantum · re
ligio · potui
t · fuadere ·
malorum ·

Cutting a mask for sand-blasting

Briem showed Timothy, in one rushed afternoon, how
to cut a mask for sand-blasting. He traced the letters
on to adhesive paper and fixed this carefully around a
tall glass container. Then he cut out the drawn letters
with a sharp blade. Timothy learned quickly and this
technique worked well with his bold letters. This was
his first attempt. He explained disarmingly how he got
the quotation to fit. He wrote 'The quick brown fox . .
.' until he had covered a collar the same size as the
glass. Then he searched for a quote of the same length.
The 'm' is the same size as the original.

Building up letters Timothy demonstrates a way of building up written italics. You can see quite clearly where he has added strokes to strengthen the letters; it is mostly near the terminals. He says that it takes quite a while to become consistent enough to write out a whole passage this way. You can use this technique to strengthen your headings.

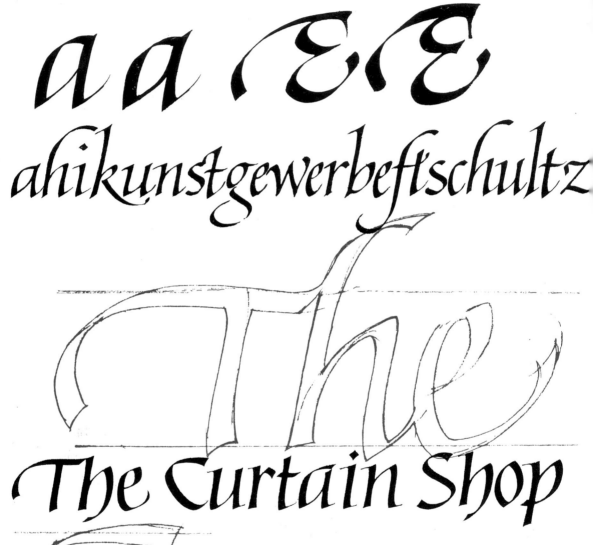

Timothy is sometimes asked to design shop fronts. He uses double pencils to help draw the large letters that this requires. Later these letters will be painted or silk-screened on to their final position. Notice how he uses his 'thickening-up' technique on top of the double line. It gives the necessary strength and subtlety to the letters once the double pencil has roughly sorted out the thick and thin strokes.

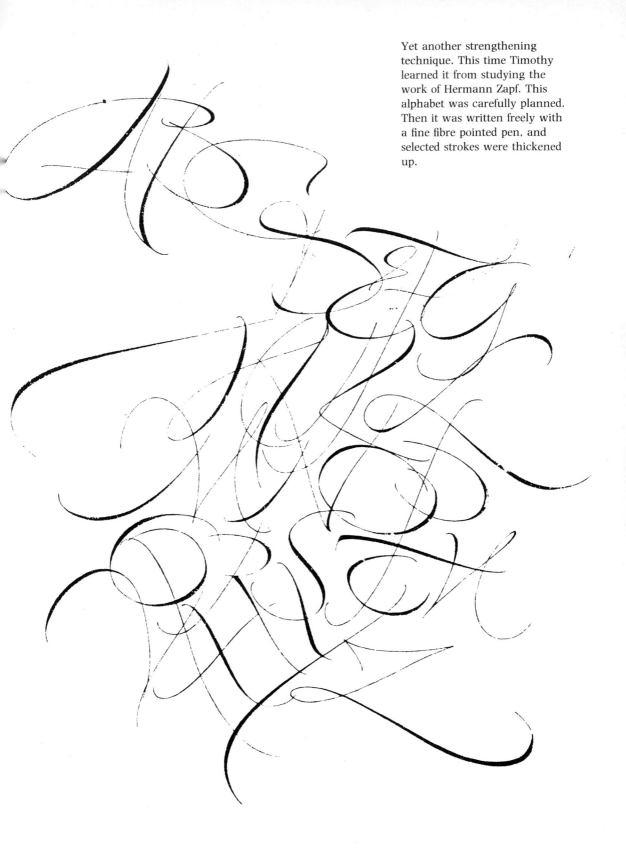

Yet another strengthening
technique. This time Timothy
learned it from studying the
work of Hermann Zapf. This
alphabet was carefully planned.
Then it was written freely with
a fine fibre pointed pen, and
selected strokes were thickened
up.

Patrick Knowles

Patrick became interested in lettering as another form of visual expression while he was still at school. He took a Foundational Course, intending to be an illustrator, and then a three-year graphics course before going on to further postgraduate studies.

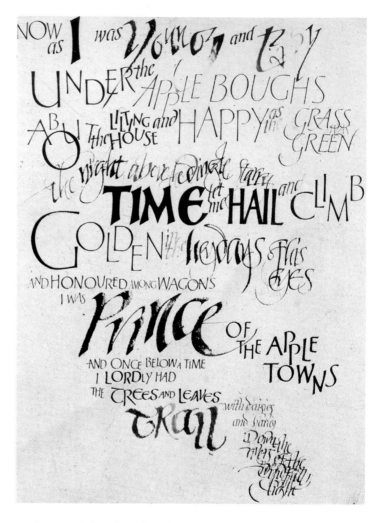

Patrick did this calligraphic composition during his postgraduate year. He says, 'It is meant to be read rather than just looked at as a whole. It attempts to convey the rhythmic and audible sensibility of the words, using the visual expression of the letters.'

Some of the details of this piece show that Patrick had put quite a lot of work into his study of capital letters. On the whole, his freer letters such as 'Green Grass' are happiest. You have to be careful how you move about more formal letters. 'Lilting' perhaps tilts too much.

Designing for letter-cutting

Patrick had some lessons in stone cutting from Alec Peever before designing this house sign, to be cut in slate. His rough sketches show imagination and growing confidence. There is nothing like the motivation of a real commission to sharpen up your ideas.

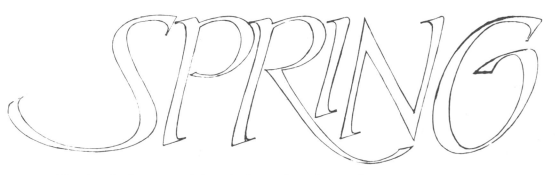

The finished tracing (above) shows how he used a combination of the sketches. He retained the flowing 'S' from the third sketch with the more formal letters of the fourth. Then he extended the flourish of the 'R' to contain the whole of the 'N' and the nestling 'I'.

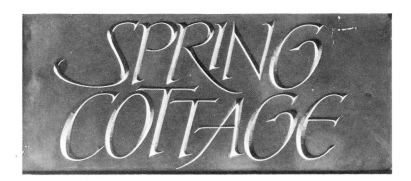

Fiona Winkler

Fiona had just completed a year's Foundational Course when she answered an advertisement from Alec Peever's Lettering Studio. He wanted an assistant to help with all aspects of his work. He said, 'The applicant has to have an interest in making things. There is no need to know about lettering'. This was just as well, as Fiona had not been exposed to lettering during her course. To remedy this, she enrolled in calligraphy classes one day a week, and the rest of the time learned in a practical way in the workshop.

SIGNED SEALED and DELIVERED by the said

These freely interpreted Uncials came from the rough draft for a trust deed. The lettering shows a bold, legible and imaginative use of one of the hands she studied on her course. Studying historic letterforms does not mean always reproducing them exactly. When Fiona developed these letters she put a lot of her own personality into them.

Two rough sketches for a wood engraved book plate.

The client's final choice was a design with delicate traditional letters. The tool marks made such an interesting texture in the border that it was a pity they would have to be cut away. In other circumstances they might have been incorporated into the design.

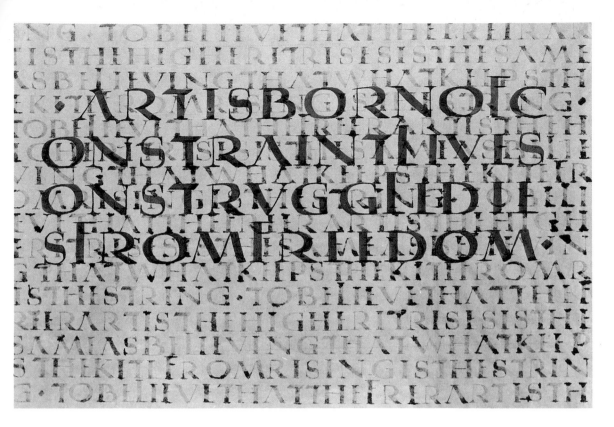

Fiona is more interested in learning techniques than in producing finished work. This piece was lettered on a large sheet of thin paper, and the square Roman capitals of the main quotation 'Art is born of constraint . . .' are written in watery burnt sienna ink. The background wording is written *in reverse* on the *back of the paper*, and shows through as a speckled sludge colour.

Having seen how effective the square Roman capitals could look in different tones, Fiona used them in her next job, which was a wedding invitation. The finished card was printed in tones of ochre and looked most unusual. Notice the asymmetric line spacing with a careful balance of text and white space.

YOU ARE INVITED TO
THE WEDDING OF
SIDONIE & JOHN
AT THE CHURCH OF
SAINT MICHAEL & ALL ANGELS
CLIFTON HAMPDEN
OXFORDSHIRE
ON SATURDAY 10TH JULY
AT 12 NOON
AND AFTERWARDS AT
LOWER FARM HOUSE
CULHAM

RSVP · 3 CEDARS ROAD · HAMPTON WICK · KINGSTON-UPON-THAMES · SURREY ·

Rustic capitals

This page shows how deeply a serious student like Fiona Winkler goes into the details of mastering historic hands. Here is a whole page concentrating entirely on the terminals of Rustic capitals. Notice the angle at which the pen is held. It is almost the same as that suggested in the exercise on pages 20–21.

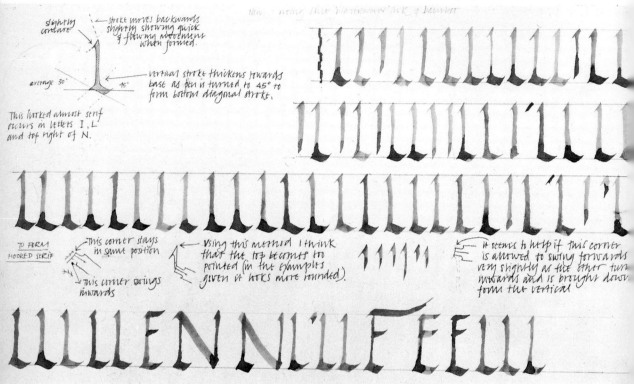

Reproduced same size, the work shows how Fiona strives for a good consistent serif. Once again she writes with watery ink on detail paper, using a bamboo cane. You can cut yourself a bamboo pen with a very sharp blade in much the same way as you cut a quill. Then you can cut a thin metal strip and bend it into shape to make a reservoir, which will ensure adequate ink flow for larger letters.

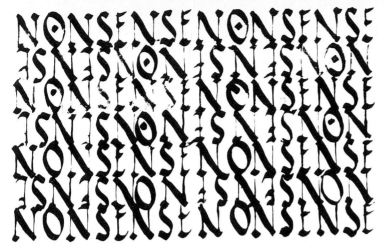

After all that effort why not use this unusual hand? This page shows how lightheartedly Fiona used these fifth-century letters, this time without modifying them at all.

The repeat patterns were sketches for end papers to go in a book of nonsense rhymes. Notice how the unfamiliar balance of weight, thin uprights and thick horizontal strokes, add to the interest of these patterns.

THE GREAT PANJANDRUM

Fiona is gradually being exposed to all aspects of Alec Peever's work. Naturally, she still works under his guidance. So to a certain extent, any finished work is a product of the studio, not just of one person. This constant exchange of ideas is something that a solitary craftsman misses. Fiona is asked to do a diversity of jobs, progressively more skilled. She cannot help being influenced, at this stage, by the letters she sees around her, just as Alec, in his early days, was probably influenced by the stone cut letters of Richard Kindersley, who taught him. On the other hand she brings to the partnership her enthusiasm for calligraphic form that in turn rubs off on to Alec. They both feel, after two years, that she has done enough calligraphy. Too much dependence on a broad edged pen could result in lack of strength and subtlety in drawn letterforms.

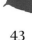

Planning an inscription

Here is a record of Fiona's first commission for an inscription. This is a copy of the sheet she submitted to her client for approval. It included details of each of the different sizes of letters, and clearly shows their design. Then there is a rough layout of the whole inscription. Together this is enough to enable anyone to envisage the finished job.

THIS PL

HRH

TO THE P

THIS PLAQUE RECORDS THE VISIT OF
HRH PRINCE OF WALES KG
TO THE PIRATE CASTLE ON 1ST JUNE 1982
FOR NAMING NB PIRATE PRINCESS

A detail from the tracing shows the actual size of the lettering on the carved inscription (right).

With her next commission Fiona launched out into flourishes. These are notoriously difficult to design and balance. Just like the letters in her first commission, these show a sense of strength, unity and movement that point to a promising future.

Designing for stone and glass

In the workshop Fiona is lucky to be able to work with a variety of materials and to be able to exploit their varied characteristics.

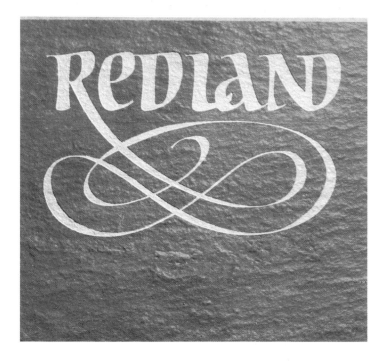

This commission was intended to show off the new material it was worked on. Therefore the placing of the lettering on the block is unusually high. It was sandblasted on to Petrarch — a reconstituted slate. The design itself would make a good logo type as well.

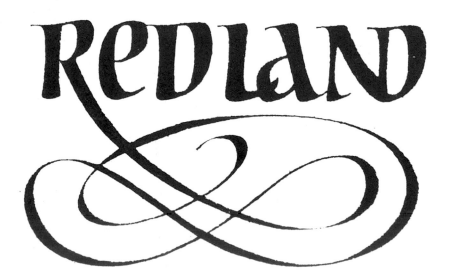

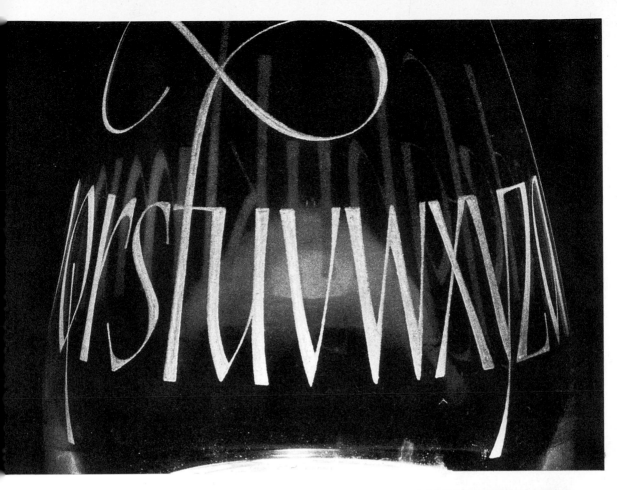

Fiona feels that this engraved decanter marks a fresh stage in her development. It was a new technique for her, having to learn to use a dentist's drill; but it was also learning to design and control letters that, as she put it, 'fell away in two different directions', around the decanter, and upwards as well, as the glass neck narrowed.

Fiona says the letters evolved in her head, and she transferred them to the glass with a felt pen. She felt the sequence q–z came off best. But clearly it is all well designed and shows a sensitivity to the shape of the decanter. The soaring flourishes accentuate the slender neck, and contrast with the simplicity and strength of the alphabet below.

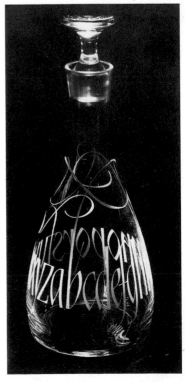

Judith Hammer

The last three contributors were all in their early twenties. Judith Hammer shows that you can take up lettering later in life and still make a success of it. She has trained part-time for five years, and has recently finished a diploma course in Calligraphy, Heraldry and Illuminating. Now she intends to teach students in Adult Education and do freelance work as well.

This lettering was first of all painted on silk and intended as a wall hanging. The Latin quotation, written continuously within a square, was then adapted to be silkscreened for use as a cushion cover. Finally, Judith realized what an effective repeat pattern it would make, and the curtain was printed. This is how the letters were developed. The exercise started with a study of the work of Ben Shahn, but as the design progressed Judith put her own ideas into the forms. She also had to take the material into account. The letters were straightened because of the problem of painting over the grain of the silk.

To make the screen, the letters had to be painted on to Kodatrace with process black. It was important that they were absolutely opaque so that the design could be transferred photographically.

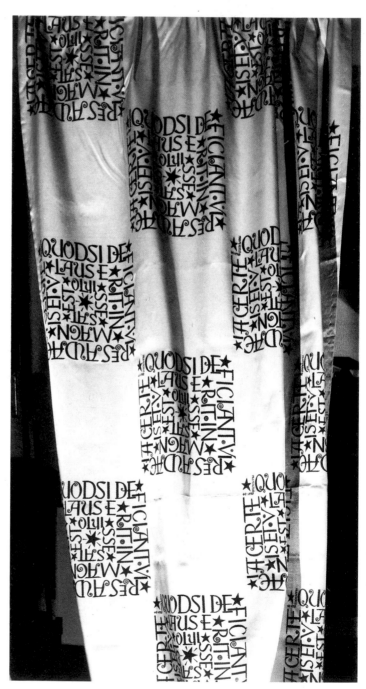

BENEDICITE

O ye Wates that be above the firmament Bless ye the Lord, Raise him and magnify him forever

Judith wrote out the Benedicite in a horizontal format, and bound it as a book. This is the title page; the original was in Prussian blue and gold.
Each page had a similar layout but used a different combination of colours. This work emphasizes the traditional content of her course.

This two-colour book jacket shows how Judith applied her calligraphy for an early commission. She used an automatic pen on a rough surface to produce an interesting texture.

DIETRICH BONHOEFFER

The Cost of Discipleship

BONHOEFFER The Cost of Discipleship SCM PRESS

Lida Lopes Cardozo

Lida's recent work appears later in the book (pp. 100–104), but she has kindly lent two pages of her early sketches that are relevant to this section. This design for a church magazine was the first job she was set at David Kindersley's workshop. She says that it demonstrates clearly that she was straight out of art school. 'It shows all the possibilities spreading over the whole surface rather than the deep digging you will do later on.'

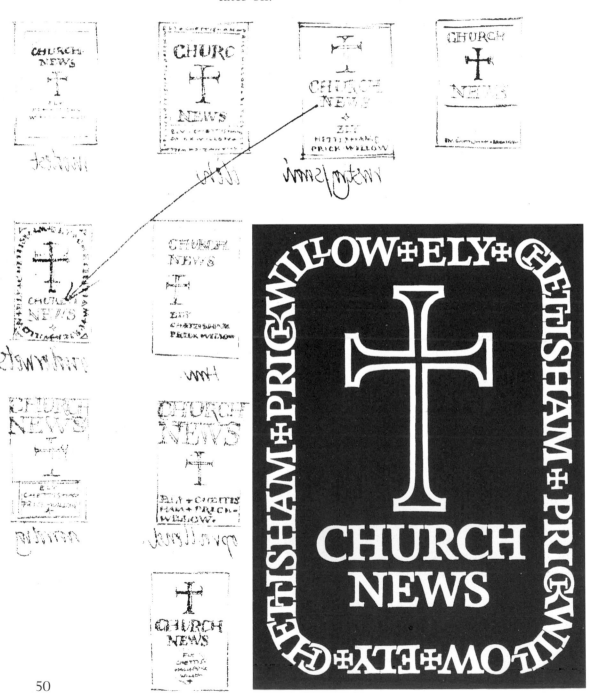

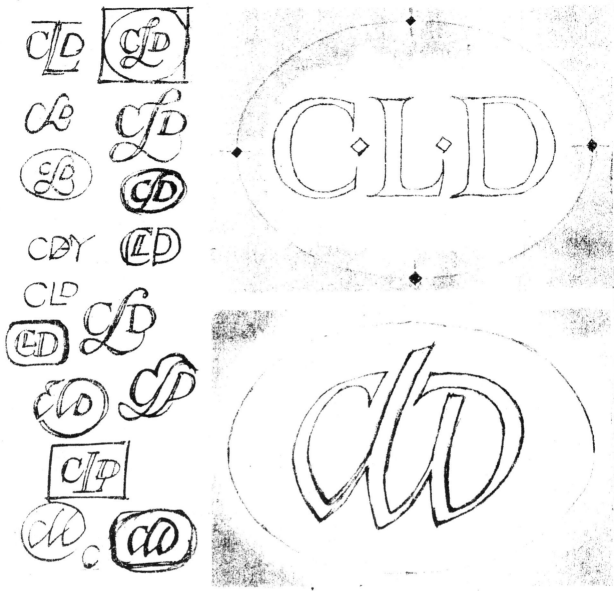

These monograms for a slate paperweight show that she is still thinking the same way. Lida says that at art school you design in a hypothetical situation where you cannot exclude any possibilities, but in the professional world work is aimed. 'You should develop the initial idea and not allow yourself to wander or you will see two ideas in one stone.'

In listing the qualities she looks for in an aspiring letter cutter, Lida rates very highly an ability to concentrate. With an inscription, the commitment and therefore the concentration can be counted in weeks, not days or hours as other lettering might demand.

Bettina Furnée

Bettina, from Holland, was heading for an academic career when an *au pair* job in London did not work out as she expected. Her only contact in England was Lida. As she had never been exposed to letterforms, the impact of David Kindersley's workshop was immense. Bettina demanded a pen and a corner to work in, and was given an Italic model to copy. She mastered it in a day and, echoing Lida's earlier determination, has never looked back. Away from familiar influences, she was more open to an opportunity that showed up her creative potential. A brief return to university persuaded Bettina that her priorities needed to be changed.

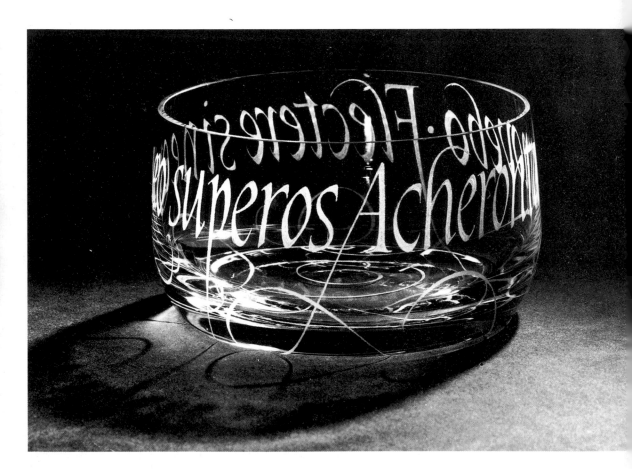

Early examples of Bettina's glass engraving. Notice the clear cut shapes of the glass she has chosen. Lida suggests that absolute beginners can start on a milk bottle, progressing to a straight-sided tumbler. As she says, 'To start with a curved surface may give some unnecessary irritation that one can well do without.'

52

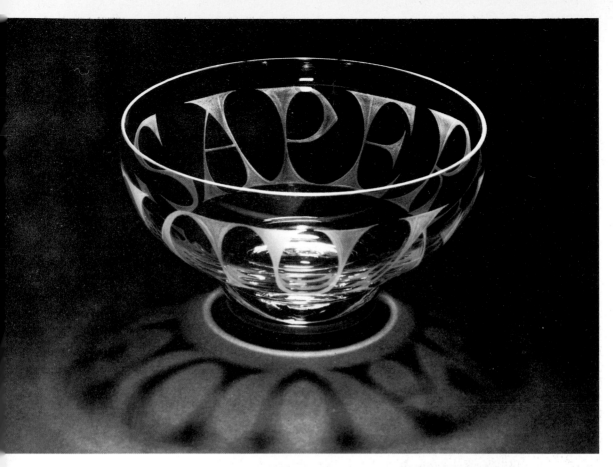

Of these two striking bowls of Bettina's, Lida says, 'They show that a strictish upbringing in "good" lettering does not kill innovation and experimentation, but that the right proportions will survive and make the wildest lettering look balanced.'

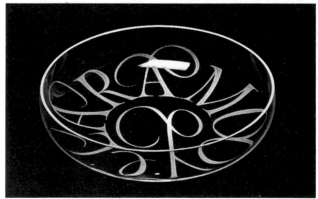

54

Learning Roman capitals

These two pages show how Bettina was taught Roman capitals. First she drew her own letters and then David Kindersley went through them separately, re-drawing each one and, most important, explaining the reason why. This way Bettina felt that what she was learning did not just apply to 'that' particular letter but to any other O or M, for instance, in the future. She says that once Roman letters are in your system you can do almost anything. When she was introduced to lettering, Bettina was surprised to find that the area between letters was just as important as the letters themselves.

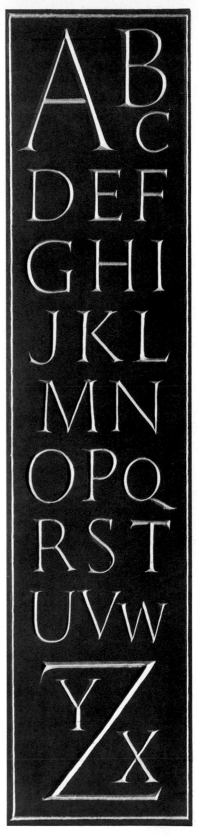

This was her first stone-cut alphabet. She had trouble spacing it and it was David's idea to reduce the size of the Q and W. Perhaps this led to the X Y Z solution, and it certainly added to the character of the layout.

These letters speak for themselves. Anyone wishing to improve their Roman capitals would do well to study these same size letters and the page opposite, and deduce from them the concepts that David was teaching.

Part three
Working with
letters

THIS PART OF THE BOOK is about the work of
professional letterers and the variety of their work
shows the many possibilities open to the beginner.
Some letterers concentrate on work for reproduction
and seldom venture into three dimensions. Others do a
bit of everything, while a few specialize in letter cutting
or glass engraving. After all, some of these techniques
take years to perfect.

None of the work has been done specially for this
book. The craftsmen show the kind of jobs that make
up their working lives, plus a few pieces that have
been produced for exhibitions. They have lent their
rough sketches and working drawings too. These are
most valuable for showing how letters have to be
adapted to suit the different materials involved. They
demonstrate the contributors' different approaches to
building up letters and solving problems (note
particularly their treatment of serifs), but they also
give the uninitiated a glimpse of the immense amount
of planning that goes into even the simplest lettering
commission. How much is done in the head and how
much on paper depends on the individual, but it is
clear that spacing and positioning always need to be
carefully worked out. When transferring the design to
the final material, the letters may in some cases be
barely indicated, and the tool allowed to influence the
final details.

The previous section dealt with the necessity for a
good grounding in letterforms. This has to be allied to
a thorough knowledge, and respect of your tools and
material, which can only be attained through practice.
Then you must be sensitive to the suitability of letters,
not only to subject-matter, but even to the grain of a
certain piece of wood. It is not a good idea to impose
preconceived ideas; let the shape of a goblet or the
reflections through glass influence your letterform. In
the case of a carved or painted inscription, the height,
angle and perhaps background of its eventual position
will have a bearing on the design of the letters. There
is also the individual's personal concept of the relative

importance of content, letterform and material to be taken into account. This aspect comes out even more clearly in the comments and sketches than in the reproductions of finished work.

There are several attitudes to creative work. Painters may get most satisfaction from producing from their imagination something beautiful that expresses their creativity. A designer, on the other hand, usually gets most satisfaction from creating something that ills a need, by designing something functional. Whereas the painter may find it frustrating to work to a brief, the same constraints can spur a designer to greater efforts. A craftsman, as a matter of fact, is often a bit of both.

The time will come when your attitude to briefs will change considerably. A client will be commissioning you not just because he needs a certain piece of lettering, but because he wants an example of your workmanship. Then there is likely to be much more freedom of design.

With luck, these clients will be well-informed, knowing what they want and respecting your judgment. If not, you should be able to do what you think right, and persuade the customers that your interpretation is in their best interests or even their own idea in the first place.

We are lucky to be paid for doing what we enjoy most of all. But it takes a lot of work and often considerable sacrifice to build up any kind of lettering practice. I have not seen anyone making a fortune out of it. What is more, looking around, it seems easier to make money out of bad lettering than good. That is certainly not what we intend to show you here.

Artists and craftsmen are constantly changing. What occupies their thoughts and influences their work one year may have changed by the next. This is what leads to progress.

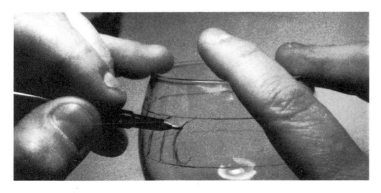

Drawing on glass in preparation for engraving.

Gaynor Goffe

Gaynor met her husband, Tom Perkins, when they were both training at art school. She later worked for three years as assistant to Donald Jackson. While Gaynor has continued to specialize in pen lettering, she also teaches and freelances. The work chosen for these pages accentuates the 'applied' side of her calligraphic work. In addition, she undertakes the traditional work of a scribe, such as handwritten and illuminated books.

The German Wine Institute, Mainz & Count Matuschka-Greiflenclau,
The Chairman of the Association of German Wine Estates,
request the pleasure of the company of

at a tasting of German Wines with luncheon
at La Tante Claire Restaurant, 68, Royal Hospital Road,
London SW3 on Monday, April 28. 1980, at 11·30 am

R·S·V·P·
Wines from Germany Information Service, 121 Gloucester Place, London W1

This example shows the way in which carefully designed and executed hand lettering adds distinction and individuality to an important invitation, setting it apart from anything that could be achieved with typesetting.

ABCDEFGHIJ
KLMNOPQR
STUVWXYZG

These controlled, slightly condensed Italic capitals come from one of Gaynor's teaching sheets.

58

it all depends upon

DR·T·SUZUKI

the adjustment of a hinge whether a door opens in or out

The impact of this lettering comes from the striking use of descenders and the texture of the contrasting sizes.

This poster, combining Gaynor's lettering with her sensitive plant drawing, was also used as a private view card for the exhibition. The original was printed in brown on cream.

If you are left-handed, do not assume that it is necessarily a handicap. Gaynor's work shows that it has not been any problem for her.

An Exhibition of

POTS
FOR
PLANTS
&
FLOWERS

Open to all
Full Members
of the
Craftsmen
Potters
Association

☿

12/23 MAY
1981

At the Craftsmen Potters Shop
WILLIAM BLAKE HOUSE · MARSHALL ST·
LONDON W1V · 1FD · PHONE · 01 · 437 · 7605

**Calligraphy
for reproduction**

These advertising cards show Gaynor's personal style. Her capital letters are particularly strong. I asked her whether Tom's stone-cut letters influenced her. She said that naturally they discuss their jobs, but there is no conscious influence – perhaps a slow, subtle, visual infiltration. Possibly the same could be said of her time working with Donald Jackson.

Notice how she changes the weight of her letters in this layout. The exercises on page 16–17 encourage you to do the same.

The openings for using good hand lettering in advertising are boundless. A direct, flexible and sensitive interpretation of the subject makes it an obvious choice for dealing with publicity for other crafts.

EXHIBITION AT CRAFTWORK · EXHIBITION AT CRAFTWORK
28 OCTOBER/ 8 NOVEMBER 1980 · 28 OCTOBER/ 8 NOVEMBER 1980

WOOD FIRED POTTERY & WOVEN TEXTILES

BY Andrew McGarva BY Jun Tomita

AT CRAFTWORK IN THE MARKET · 33/34 THE MARKET · COVENT GARDEN · WC2 · TEL 379·7961

PRIVATE VIEW Monday 27 October 6/8 pm

This page shows how to do a simple colour separation.
The card, originally printed orange and black on a
white ground, required separate drawings with careful
registration marks on them.

 The first drawing represents the solid colour. It will
be photographically reversed black to white and
printed in red. Then the second colour (below) will
overprint.

28 OCTOBER/ 8 NOVEMBER 1980 · 28 OCTOBER/ 8 NOVEMBER 1980

OO FRD & OE
O EY TXIE

BY Andrew McGarva BY Jun Tomita

PIAEIW Monday 27 October 6/8 pm

EXHIBITION AT CRAFTWORK · EXHIBITION AT CRAFTWORK

W ED W V N
I E E T L S
P TT R

RVT VE

AT CRAFTWORK IN THE MARKET · 33/34 THE MARKET · COVENT GARDEN · WC2 · TEL 379·7961

Gunnlaugur
SE Briem

Briem certainly had an international training: his formal art education started in his native Iceland and he studied letterforms in Denmark and Switzerland. He finished his postgraduate education in London with a PhD from the Royal College of Art. He described himself as a designer who specializes in lettering, but would not call himself a calligrapher. His lectures on the alphabet are usually within a historical framework.

He seldom uses a broad nib for finished lettering and thinks calligraphers tend to be held back by taking the pen too seriously. Letters can be produced by other means: the characters on the left were made with a roughly cut carrot.

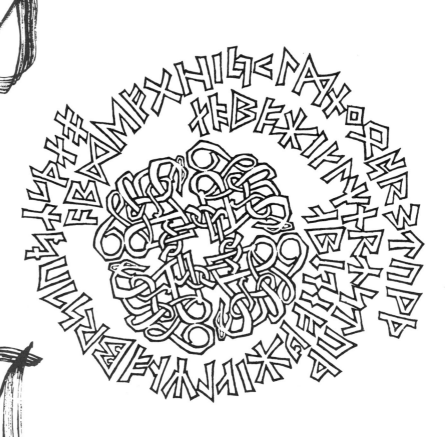

Briem's background is a strong influence in his work. He draws frequently on medieval Icelandic forms of ornament. This drawn design for instance shows the three periods of the futhark, the runic alphabet. But even in solutions of contemporary design problems his fascination with history is usually a strong factor.

Fimmtu-
daginn 4 nóvember
heldur Gunnlaugur SE Briem
fyrirlestur
BREYTINGARÖFL Í
STAFRÓFINU
á vegum
Deildar bókavarða í
íslenskum rannsóknarbókasöfnum
í Arnagarði, Stofu 301,
kl hálf níu

⁓

veitingar

annan apríl að Skipholti 1. Það er opið frá
fjögur til tíu virka daga og tvö
til tíu um helgar. þangað til við lokum þann
átjánda. Við vonum að þú getir komið.

These examples show how much can be done with a semiformal handwriting in a carefully designed framework. Briem says 'If you spend enough time on the layout of a handwritten piece, the odd roughness or unintended slip should not worry you.'

This is what sets it apart from typesetting and lends it the character of hand lettering.

Notice how effective black-to-white reversal can be. But if you want to use this technique you must make sure that there are not too many hairlines, and that the letters themselves are strong enough to stand out.

Poster design

These two designs show how strikingly simple letters without ornament can be used.

Briem had been thinking for some weeks about the problems of a slanted Roman next to Italic letters. And when a bilingual poster was needed it seemed just the occasion to try it out. He says: 'As it developed, it was less a problem of lettering than of layout. The slant of the dividing line follows the tilt of the letters. That did not call for deep meditation. But fitting the text into groups that worked in the construction without calling attention to themselves was a lot of work.'

Here are the two alphabets that are used in the poster. The strong and very personal letterforms would make a good typeface.

Opposite
This poster offered Briem an opportunity to use the historical combination of upright Roman capitals with lower case Italic, in this instance with an exaggerated body height. 'Every original piece takes a risk somewhere,' he says. 'When I looked at the final drafts, the wide letter N looked disproportionate but did not seem out of place. So I kept it in.'

International
exhibition
of calligraphy

Living
Letters

Alþjóðleg
sýning á
skrautskrift

College of
Art and Crafts,
Iceland

Lifandi
letur

Easter 82

Myndlista- og
handíðaskóli
Íslands &
Gunnlaugur SE Briem

Páskar 82

abccdeefgg
hkmnoprro
ssttuxyv -
aderfaghiijj
klll mnnuyþ
ooð&ᵹtuvits

Gunnlaugur SE Briem presents

Einar Hákonarson ETCHINGS

21 NOV - 2 DEC
Monday to Friday, 9:30 to 16:30
Paperpoint, Wiggins Teape plc
130 Long Acre, London WC2

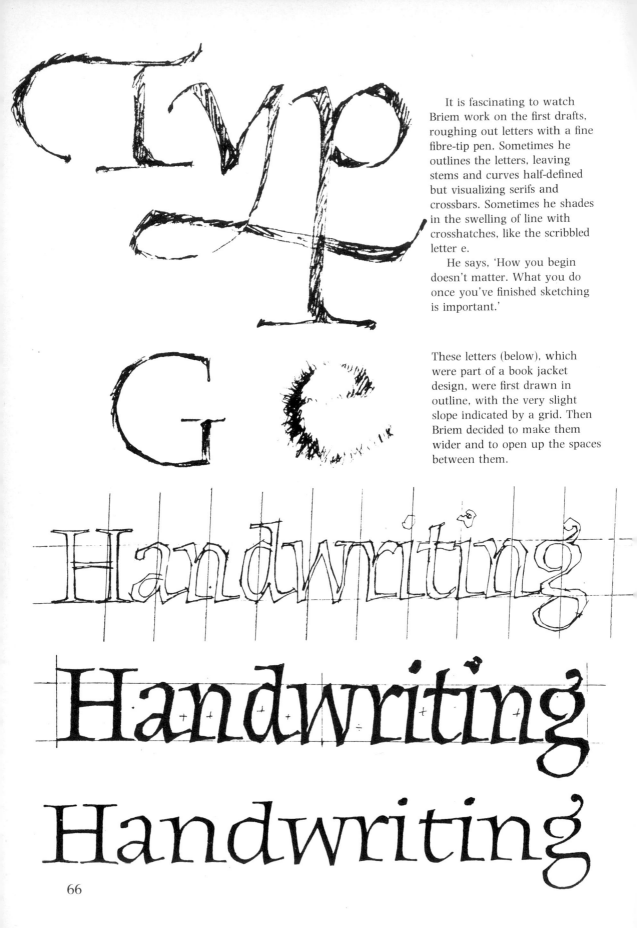

It is fascinating to watch Briem work on the first drafts, roughing out letters with a fine fibre-tip pen. Sometimes he outlines the letters, leaving stems and curves half-defined but visualizing serifs and crossbars. Sometimes he shades in the swelling of line with crosshatches, like the scribbled letter e.

He says, 'How you begin doesn't matter. What you do once you've finished sketching is important.'

These letters (below), which were part of a book jacket design, were first drawn in outline, with the very slight slope indicated by a grid. Then Briem decided to make them wider and to open up the spaces between them.

yesterday

Building up letters
The design of display capitals

Briem explains, 'I stumbled across a few interesting possibilities when I was toying with a pen. I had been thinking about split caps for a while but without any notion of what I might do with them.

'A few days later I added some more characters and started to notice some possible patterns of letterforms. I went through heaps of tiny sketches to try out things like variable curve combinations.'

Briem explains the next stage: 'Once the basic letterforms had been sorted out I ran photocopies of what I had to work with. This never encourages crisp artwork but mine tends to be an unspeakable mess anyway. I cut things out and move them about; I retouch with typing correction fluid that little by little builds up into hillocks and mountain ranges.'

You need to look closely to notice the subtle changes between the intermediate letters and the final ones on the next page.

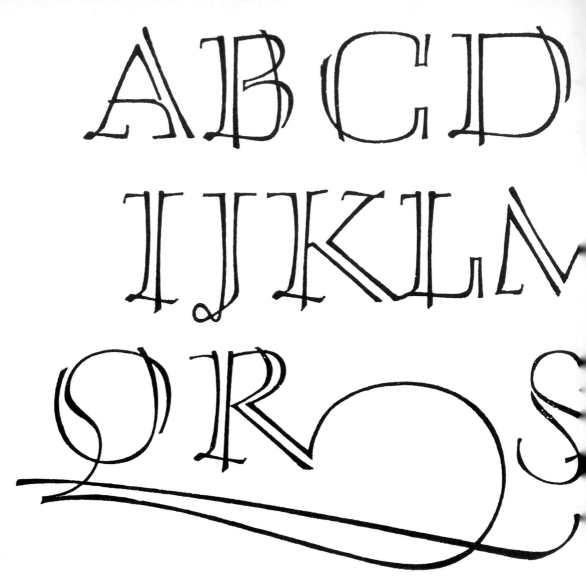

Display capitals

This is how the finished alphabet looks. Briem still is not satisfied. He says, 'The split caps are still "work-in-progress" even if I have already run an edition of prints. They need refining. I'd like to work towards a lighter texture.'

EFGH

NOP

TUVW

YZ

VISIBLE
The research journal concerned with all that is involved in our being literate
LANGUAGE

CALLI-
GRAPHY
ISSUE

Volume XVII Number 1

When Briem used the split
caps on a magazine cover he
wanted a sturdier version. The
character combinations offered
the opportunity of playing with
two letters S side by side.

The sketches show how
much control was imposed in
the later stages of work.

The Author's page

Teaching and writing have taken up so much of my time that I have not been able to produce much work recently. I have also become increasingly involved with research into handwriting problems. Anyhow, I would describe myself as a designer who uses letters and lettering techniques rather than a designer of letters – and the design of letters is what this section is really about. However, I would like to include a few examples if only to persuade calligraphers to use their skill with a pen more widely and imaginatively.

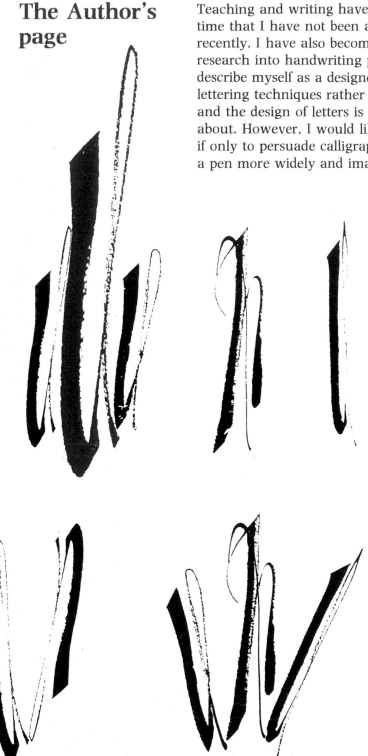

Trying to find an easier way to construct a free calligraphic design, I hit on this method.

Stage 1. Take four flourished lines (the red stroke shows the original size).

Stage 2. Arrange them into interesting units.

Stage 3. Place photoprints of the units roughly in a circle. This design repeated seven times.

Finally divide the circle geometrically into the required segments and stick the photoprints down carefully, measuring with dividers or a pair of compasses.

This design could be reproduced on textiles, glass or plastic; however, I am just going to print it on coloured paper, fold it in half and use it as a greeting card. It looks just as good reversed black to white. Then I thought of another use for my four lines, and started making letters out of them. All you need are a few rounded strokes and you could make a complete flourished alphabet.

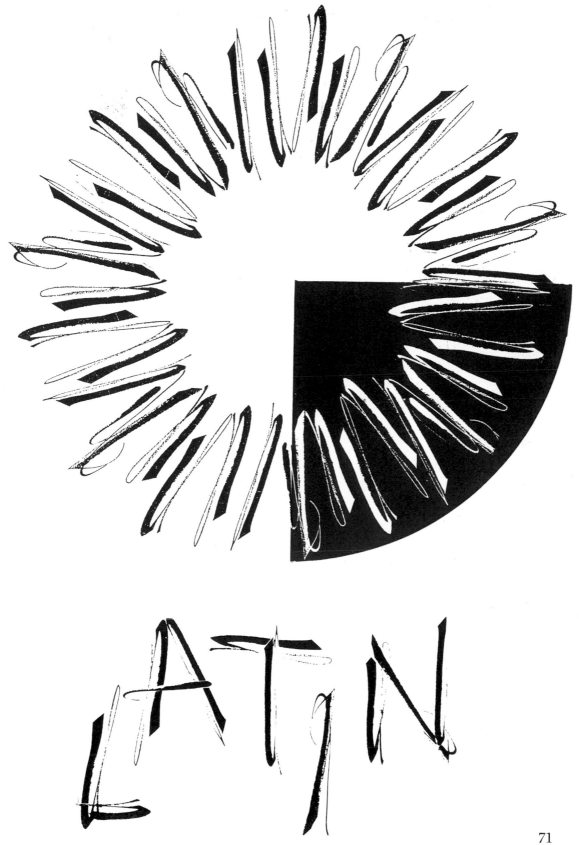

LATIN

Ray Hadlow

Ray trained for seven years, first as a painter, then as an illustrator and typographer where lettering was part of the training. He has worked as a packaging designer and as an agency typographer/visualizer. Now he is a freelance designer and typographer, and says that his main interest is in printing. His letter heading and fine glass engraving reveal his calligraphic background. This illustration also shows how a complicated piece of glass can detract from the lettering – but if that is what the client orders there is nothing much you can do.

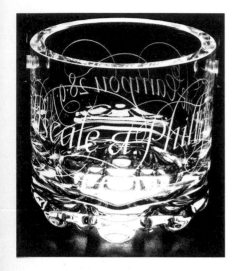

This monogram roughed out with a felt tipped pen came out so well that Ray did not consider that it needed working up. He feels that letterforms are a most subtle form of expression; however, you need to design carefully. 'If you get anything wrong it stares you in the face and you cannot disguise it.'

Design Practitioners Limited | Type Practitioners Limited

Ray says that designing logotypes requires an ingenious twist of mind. He does most of the work in his mind, then he 'tightens up' his scribbled sketches mechanically, often using a grid to enlarge them. He advises anyone who designs logos to keep them strong and simple. You never know how they will be used, any size from minute on a letterhead to enormous on an advertising hoarding.

'A professional should have a wide range of skills and should be able to turn a hand to anything', said Ray about this Greek, Cyrillic and Chinese lettering. He designed these headings for a set of language-course book jackets.

Scarab Jewellery

中 文 课 程

Инструкции Комментарий

ΕΠΕΞΗΓΗΜΑΤΙΚΕΣ ΠΑΡΑΤΗΡΗΣΕΙΣ

Tά 'Αγγλικά γιά παιδιά

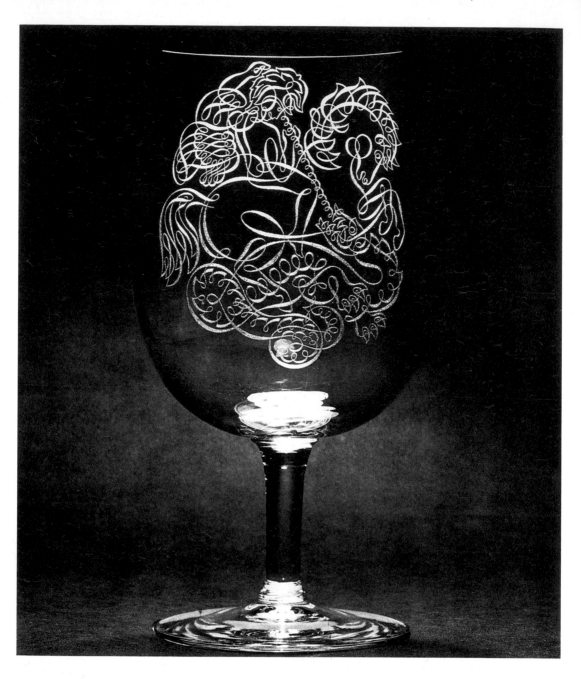

Calligraphic drawing

These pages illustrate how one design can be used for several different purposes. This St George and the Dragon was cut into scraperboard and used on the cover of a prospectus. It was reversed black to white to put on the title page, and later was engraved, with a diamond point, on a large goblet.

Ray finds the exercises on pages 22–23 interesting. He sees a direct comparison between them and the way he draws up his own designs.

LEO

Two of a set of twelve Zodiac
designs
These were first designed as
Christmas cards. Here you see
them cut in continuous
calligraphic line on
scraperboard. Several of the
months have been
commissioned as glass engraved
roundels.

GEMINI

75

Pat Musick

Pat's early training was at Reed College, Portland, Oregon. Then she studied with Lloyd Reynolds at the Portland Art Museum School where 'Rhythm, life and dance of the pen' were stressed and where skill and discipline were not considered as ends in themselves but as tools allowing freedom and life. She learned a free-flowing Italic hand and, as a professional, undertakes varied lettering commissions using different styles. However, she is best known as a specialist in Irish half-uncials, both in their history and as an exponent of insular hands. Lettering is for Pat 'a vehicle for combining arts and literary interests'. She lists among these interests membership of the Society of Antiquaries of Ireland.

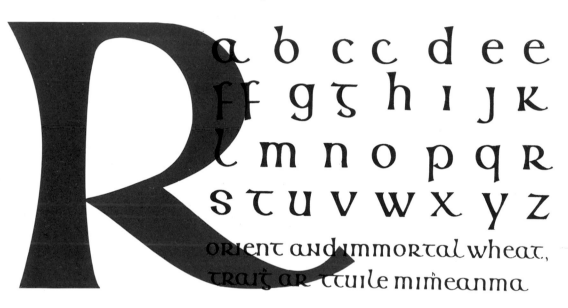

Using half-uncial letterforms

Pat Musick designed two Celtic typefaces. The top alphabet keeps fairly close to traditional letterforms. The individual letters are particularly striking when enlarged and the typeface comes into its own when used in Gaelic.

The second typeface (below) attempts to formalize and perhaps modernize the letter forms. Notice the interesting 'counter' shape (the inside shape of the round letters). These simplified and definite letters would work well in display and advertising.

Pat writes, 'Some ancient scripts are illegible enough to modern readers even aside from individual letters that are nothing like their modern forms, such as the insular majuscule (or Irish half-uncial) G. How to adapt such a letter to resemble its modern form but keep it in harmony with its parent script?' Here Pat shows a capital G. She suggests you could 'borrow a form from EX; eliminate the cross bar of the E and most of the X . . . or just steal a letter from another manuscript.'

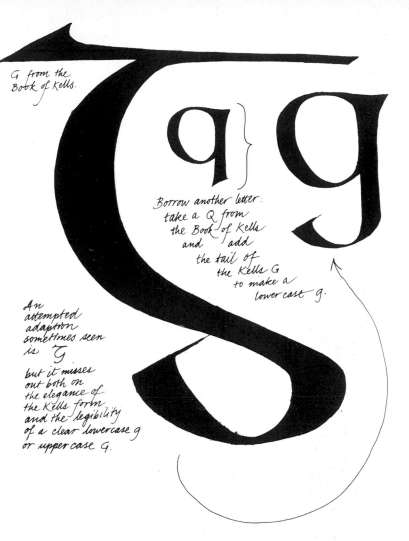

G from the Book of Kells.

Borrow another letter: take a Q from the Book of Kells and add the tail of the Kells G to make a lower case g.

An attempted adaption sometimes seen is ꝿ but it misses out both on the elegance of the Kells form and the legibility of a clear lowercase g or upper case G.

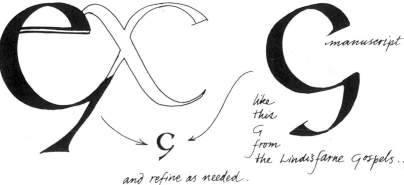

Upper case G: borrow a form from EX; eliminate the crossbar of E and most of the X ... or just steal a letter from another manuscript

like this G from the Lindisfarne Gospels...

and refine as needed.

This page is condensed from a piece about insular majuscules, written for the research journal *Visible Language*.

Lettering in enamel

Pat Musick says, 'Enamel is a medium of extraordinary brilliance of colour and durability. Many people do not realize that it is basically coloured glass fused to metal at red heat. The very word "enamel" provokes widely different responses, from Fabergé and cloisonné to the London Underground and Victorian railway advertising. Enamel has obvious potential as a mural or architectural medium because of its intense colour qualities which only stained glass can rival. New ideas and techniques continue to evolve. The richness, versatility and practical application of enamelling challenging the letterer, and the degree of formal definition required by lettering challenging the enameller.'

The preliminary sketch and finished panel of half-Uncial letters enamelled on steel.

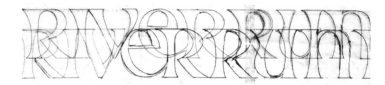

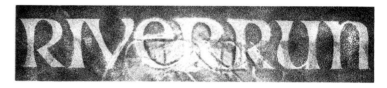

Pat Musick demonstrates three different enamelling techniques: sgraffitto, wet inlay and screen oil. The illustrations show quite clearly both the opportunities for letterforms and the constraints upon the designers in each case.

(1) **Sgraffitto** Dry enamel is mixed with a gum tragacanth solution, poured on to a panel and dried. When the design has been transferred it is cut through with a sharp tool (above left). The letters themselves can be cut away to reveal the surface underneath or the background can be cut away to leave the letters standing. If the letters are recessed, the surface of the cut-away edge reflects highlights like any other incised letter.

78

(2) **Wet Inlay technique** Enamel is mixed with gum solution to paste consistency, then it is guided on to the panel. This process permits very precise positioning of the enamel but can be very time-consuming and is best used for working on a small scale. It can be used to apply enamel to incised forms, as the term 'inlay' implies.

The enamel is being carefully used to fill in a cut-away letter. It should be slightly raised from the form inlaid, as after firing this will level out and be flush with the surrounding surface.

As designers' technical skill improves, so will their control over the letters. You can see that this technique allows, and even encourages, serifs, though it is no use expecting the precision that can be obtained in glass engraving or stone carving.

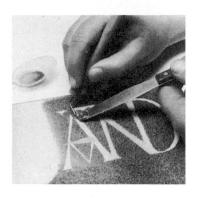

a

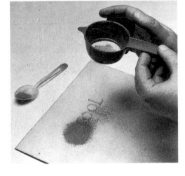

b

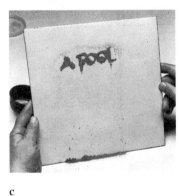

c

(3) **Screen oil** The enamel is held by the medium of screen oil lightly tinted with ink so that you can see what you are doing. This is applied with a brush (a). You can use a flat-edged brush just as you would in free brush lettering, or you can draw and paint in the letters carefully. The quality of letterforms is therefore dependent on the writer's skill. After the powdered glass has been sprinkled on through a sieve (b) the plate is shaken to remove the excess (c). This method is equally suitable for large or small work, but you must expect very fine lines to thicken up slightly. You have a chance to retouch your letters after the oil and enamel have dried, but before firing (d). Letters written in oil will end up slightly raised and will catch and reflect highlights.

This panel of screen oil enamelling (above) was freely written with a broad-edged brush in graduated and subtle tones of red, orange and yellow. Pat undertook post-graduate studies in lettering and enamelling in London where most of the work, shown here was done.

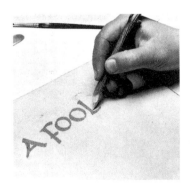

d

79

Martin Wenham

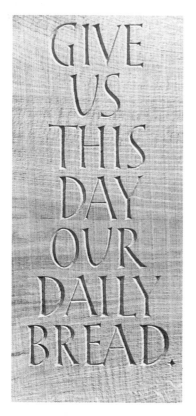

Quotation cut into an offcut of hand-sawn oak

House sign (above right) cut in oak with the letters painted black afterwards.

One of a set of samples to show the sharpness that can be obtained with a hard fine-grained wood.

It was difficult to know how to present Martin's work as he is in a different position from the other contributors. He is not at all a full-time craftsman, being a school teacher by profession. However, his distinctively personal approach to woodcarved inscriptions should interest those wanting to try out this medium. Although he has never had any training and has worked entirely alone, Martin has been interested in using letters since his schooldays.

He feels that the choice of quotations is a fundamental part of lettering: 'Craftsmen have a responsibility to ensure that their efforts and the attention of their readers are not wasted on the exquisite presentation of trivia.'

He presents wood as a warm, sympathetic material for informal and domestic situations. The useful part of his work, as he calls it, 'is carrying information in a clear and, I hope, beautiful way. Good wood signs can be made relatively cheaply and add significantly to the quality of the environment'.

HAYFIELD COTTAGE

Hawthorn

Martin cuts by 'stabbing vertically into the centre line to the full depth of the letter, then chopping out the waste with a diagonally downward movement of chisel or gouge to give the familiar 60° v-section.' Based on his feeling that the tough fibrous nature of wood favours simple, open letters, he has evolved a simple basic alphabet that he describes as 'rustic' (though not in the historic sense). He also feels that 'The technical limitations of wood offer none of the freedom of working with a fine stone such as slate, though its colour and texture open up possibilities in other directions.'

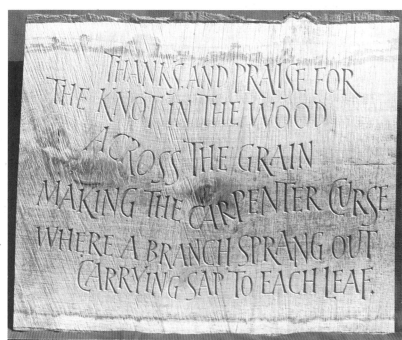

THE STIFF AND UNBENDING
IS THE DISCIPLE OF DEATH.

Notice how the shape of the hawthorn wood and the knot influence the layout of this quotation.

The letters were roughly sketched out in a straight line and counted before being transferred on to wood, where they were freely adapted to the movement of the branch. The distortion of the letters by the position of the knot added force to this quotation by Lao Tzu.

STIFF AND

THANKS AND PRAISE FOR THE KNOT IN THE WOOD ACROSS THE GRAIN MAKING THE CARPENTER CURSE WHERE A BRANCH SPRANG OUT CARRYING SAP TO EACH LEAF.

An apt coupling of a poem by Gael Turnbull, with roughly sawn oak. This piece was carved for an instrument maker in exchange for a lute

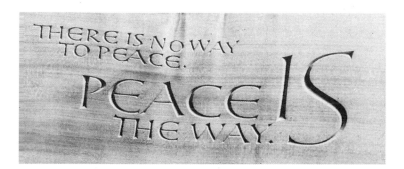

THERE IS NO WAY TO PEACE. PEACE IS THE WAY.

With this quotation, designed for an international peace exhibition, Martin is giving more thought to his actual letters. He is using a range of scale and form to emphasize the message.

Tom Perkins

A paperweight made for his baby daughter.

Interested in lettering since his schooldays, Tom was first trained as a calligrapher. Not surprisingly, in view of the strength of his work, the pen was not enough for him. He spent a valuable year learning stone-cutting and other techniques from Richard Kindersley before making the decision to set up his own studio. It's a tough life anyhow, especially if you set yourself Tom's very high standards. His work speaks for him. It shows carefully designed letters, a meticulous eye for detail, and it is beautifully executed.

Tom shares the teaching of lettering students with his wife Gaynor. He would like to do more in the best tradition of craftsmen to hand down the skills that have come to him in a direct line from Eric Gill via the Kindersley family. However, he finds the economics of having an apprentice are complicated in two ways. Few students can afford to accept the wage that a young craftsman can offer, and it takes a long time before most apprentices are ready to undertake a commercial job.

Pen sketch for advertising.

Sketches from a logo for a crafts fair. The centre one was the final choice.

This well-balanced
alphabet
demonstrates Tom's
skill with a pen.

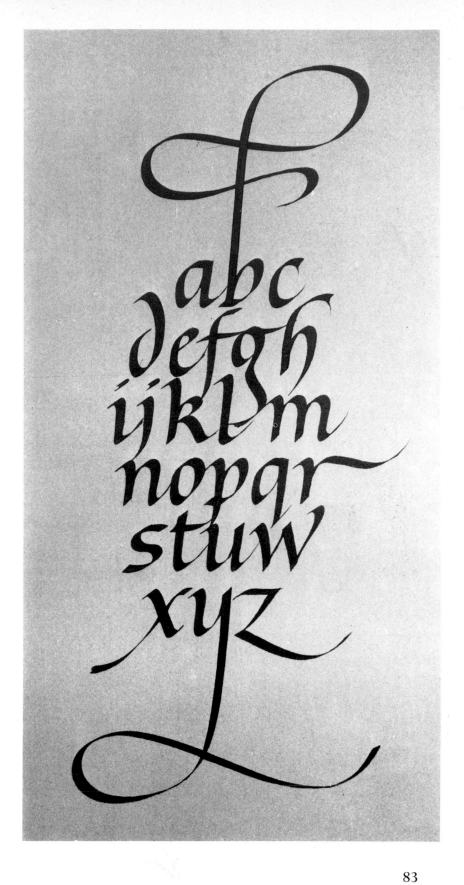

Alphabet doodles

Now you can see the origin of some of Tom's alphabets. He admits that he is a great doodler. This well-covered sheet of detail paper is nearly a yard long. It was not the only one to be found in his workshop, either. He often uses a broad-edge nib in the early stages of planning.

These letters are shown actual size to give an idea of the scale of Tom's experimental lettering.

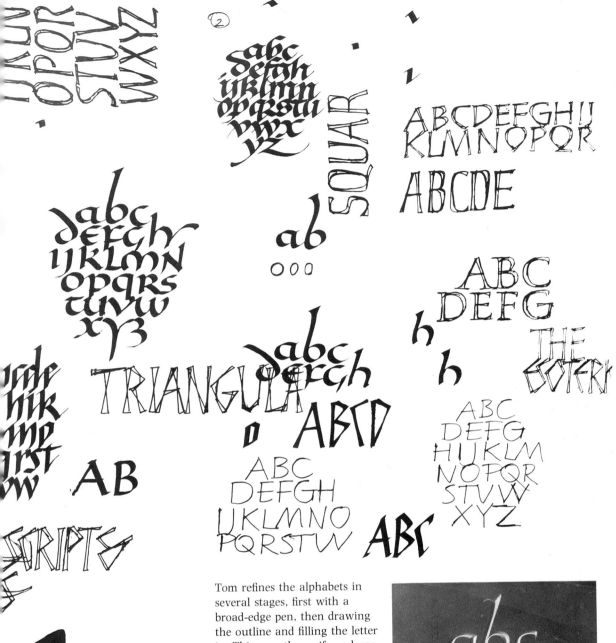

SQUAR

TRIANGULA

SCRIPTS

THE ESOTERI

Tom refines the alphabets in several stages, first with a broad-edge pen, then drawing the outline and filling the letter in. This way the serifs undergo a change, then the letters are transferred on to stone and the final details determined by the chisel. Notice how the G changes, and how the W and Z alter from the rounded pen letters to pointed forms. Yet the overall design changed very little from the first quick sketch. The finished inscription (right) measured 76 × 57 cm.

The K undergoes a change from the first broad-edge pen letter

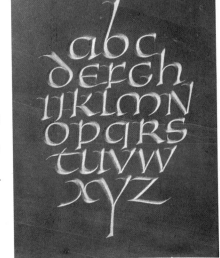

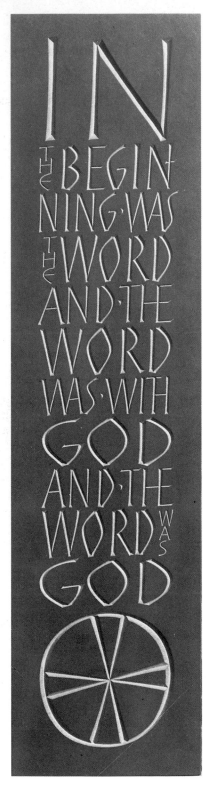

Designing an inscribed alphabet

These alphabets are both finished examples of Tom's work and a store of personal letterforms for future use. The letters he uses are in a continual state of development and refinement, the forms being adapted for specific materials and purposes.

Having seen runic-inspired forms with calligraphic influence he decided to develop an angular, compressed alphabet. He sees an evolution from the letters used in the quotation from St. John to the forms used in 'Shades and Bases'. If you combine the tops of the curved letters from the 'Fat Oxen' inscription overleaf with the angular finish at the bottom of the letters from the St. John quotation, you will see how the forms for the 'Shades and Bases' sign were arrived at.

SHADES &BASES

e Klint shades from
Denmark-pottery bases
y individual craftsmen

SHADES &BASES

LE KLINT SHADES FROM
DENMARK- POTTERY BASES BY
INDIVIDUAL CRAFTSMEN

Detail of the full inscription
This sketch, drawn quickly with
a felt tip, shows how much
Tom can plan in his head. The
only alterations he made were
to widen the flat bases of some
of the letters and to adjust the
balance of the ampersand. Then
he decided to change the
descriptive writing into capital
letters.

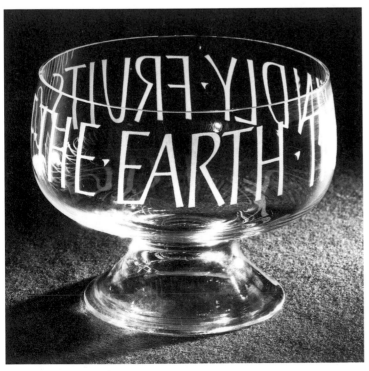

These strong, simple, engraved
letters dominate this glass fruit
bowl, showing a sensitivity to
shape and control of quite a
different set of tools and
material.

WHO·DRIVES·FAT·OXEN
MUST·HIMSELF·BE·FAT

Evolution of an inscription These two pages are based on an article written by Tom Perkins for *The Scribe*. The progressive drawings clearly show the decisions that had to be made at each stage.

WHO DRIVES FAT OXEN
MUST HIMSELF BE FAT

WHO·DRIVES·FA

The first thumbnail sketch decides the horizontal shape of the inscription.

The second and third sketches, still rough, make a decision about the form of the letters. He wants these to be related to the way a slanted broad-edge pen would characterize the form. Having a clear conception of calligraphic weighing, he does not need to use a broad-edge pen, brush, or double pencil at this stage.

DRIVES

 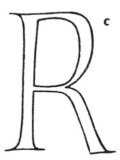

This is a diagram of the development of the letter R.
(a) Shows the skeletal form. It has already been decided that it should be condensed and squared off.
(b) The skeletal form drawn with a double point now overlaps at an angle of 25° and

shows the weight of the strokes. Tom did not need this stage but it is invaluable until you are experienced enough to visualize and go directly to the third stage.
(c) The final form developing directly from the second sketch. It shows the changes that

freehand drawing has made to the letters, *entasis*, in Tom's words, 'or the waisting on the stem and tail, and a more graduated change from thick to thin, especially where the bowl of the R meets the tail'. That leaves the careful design of the serifs until last.

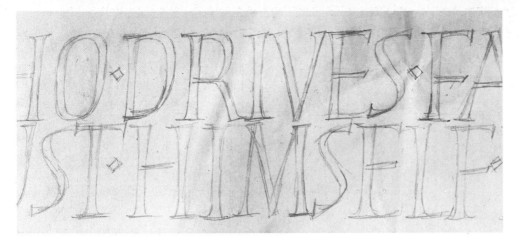

Details of the first full-size rough
drawing. Here he decided to use
'a classical bracketed serif'.

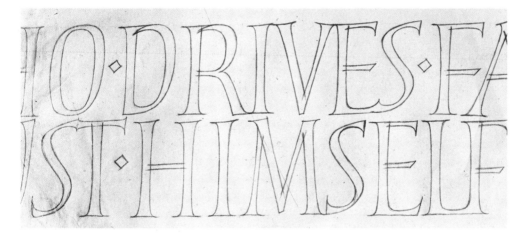

Details of the final full-sized
drawing. It was a careful
tracing from the rough
drawing. Tom explains how to
avoid losing the vital
spontaneity of your first idea as
you inevitably have to draw up
and improve your letters: 'As
long as you think through each
stage, bringing critical faculties
to bear on the problem, not
simply mechanically going
through a series of operations,
then a lively result is certainly
possible.'

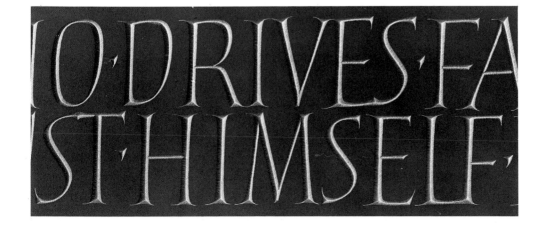

Alec Peever

Alec Peever is a letterer and stone carver, as this rubbing from his sand-blasted wooden workshop sign shows. To Alec, lettering has a visual function; to interpret and fasten the attention of the public and to fix it in their memory. He believes that 'to live, lettering should be functional. Furthermore, if lettering is to be taken seriously, craftsmen have a duty to see that it is serving the purpose it is meant to.'

Embroidery

This brush-lettered title is for a journal: Alec's calligraphic training shows in his work but he says that he uses a brush more than a pen. He prefers to do finished art-work which reflects the hand-produced technique rather than imitate the rigidity of the machine.

Church notice board. Freely painted lettering with a chisel brush.

Frayling in Road SW

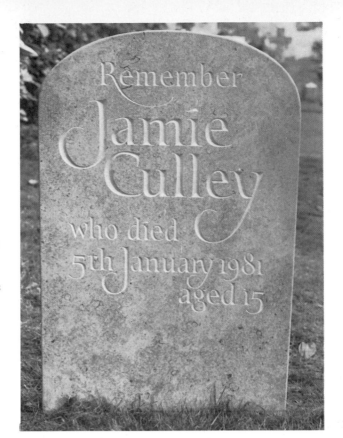

Alec believes that a gravestone should record a life, not a death. The simplicity, even informality, of this young boy's memorial shows Alec's sensitivity to the subject. Below, the first pen-sketched letters and layout get adapted by the chisel, but echo Alec's calligraphic style in stone.

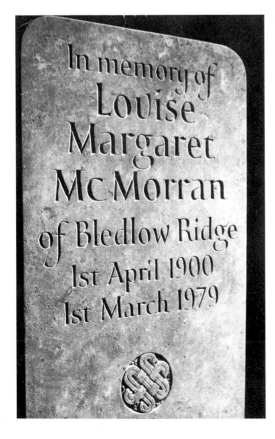

In memory of
LOUISE

91

ALL
SAINTS'
PARISH CENTRE
WAS OPENED BY
HRH PRINCESS ALEXANDRA
AND DEDICATED BY
THE BISHOP OF
SOUTHWARK
22 JULY
1983

Stone carving

The brief for this commission
was unusual, and to a certain
extent limiting, as it stated that
all the lettering should be the
same size. So Alec used the
diamond shape of the lettering
within the round stone, and the
light mobile letters to express
the occasion and the 'leisure'
use of the hall.

Same sized letters from the final
tracing and part of the finished
plaque.

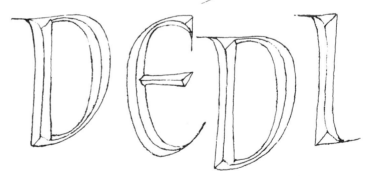

This house sign was painted on brick and then stained.
This house sign (below) has raised letters on Portland
stone. Alec says, 'Raised lettering needs a careful final
drawing, whereas with incised lettering you can draw
the letters directly with the chisel in the final
execution.'

Alec Peever says that you design for the material – on
slate you can do one thing with your letters, on brick
something else. Different materials and techniques call
for different letters.

Alec believes architectural lettering must be specially
designed and particular to one building. These 'live'
letters reflect Alec's views of the Barbican Theatre.
They are fretted out in wood and raised from the
surface of the wall. The version (right) shows an
adaptation for graphic purposes and the detail of the
serif shows the actual size of the modern letters.
Alec found it necessary to make subtle changes to his
drawings. Being three-dimensional and sculptured, the
play of light influenced the details of the final letters.

Will Carter

Will Carter brought to his wood- and stone-carved inscriptions a love and knowledge of letterforms built up over many years of fine printing. Will says it was an easy transition, and that cutting enabled him to change letters that he was used to handling in another medium. He gives the middle crossbar of the E as an example of something he could alter that had never looked quite right to him. He felt that the serif had too much fussiness and got in the way when he wanted to extend the base of the E. Will says that he was always good with his hands and enjoyed handling tools and using them, essentials for a letter cutter. He also stresses the physical strength needed. I didn't need to be reminded of that after seeing a 5 ft 5 in.-high stone inscription with 6 in.-high letters being worked on in his garden beside the river in Cambridge.

Will actually cuts more in stone than in wood but has kindly contributed examples of wood-carved letters to this section to represent a skill that is rare today.

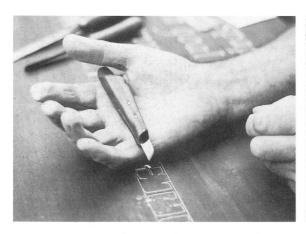
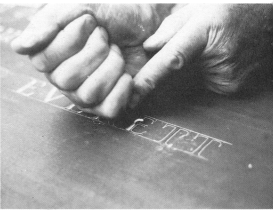

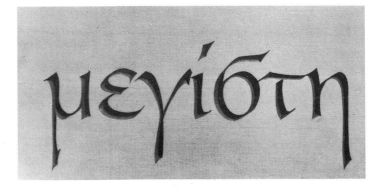

Will has evolved his own method of carving wood, which he describes as 'slicing'. These photographs show how he holds his razor-sharp knife. He says that the secret lies in the forefinger of his left hand, which controls the movement.

Part of an inscription in Greek carved in mahogany and painted, from lettering by Hermann Zapf.

The Rampant Lions Press

Will Carter finds wood a sympathetic material as a vehicle for beautiful letters. 'Certain kinds of wood are more aggressive, more of a battle to win over, but you do not meet an enemy head-on, you just avoid using them.' He does not find the grain a problem; if it were, it would show up in the roundels that he is so fond of carving.

The wood-carved sign for the Rampant Lions Press run by Will Carter and his son, Sebastian. The letters are gold on a black ground.

THE BANE ROOM

He feels that you can do more with wood than stone, although it depends on how you handle your tools. With his method, he gets 'a wonderful flow of thin line'. He defies you to get that with a chisel – he should know, being highly skilled in working both materials.

Two more examples of wood-carved signs. These finely spaced capitals are coloured red while those for the Stinehour Press are once again gold on black.

THE STINEHOUR PRESS

Typography and printing

Meeting Will Carter one gets the impression of a truly contented man who is never bored with creating classic examples of his chosen craft. He says that he is happy to be known as just a good workman. However, those who know of his contribution to letterforms would consider that something of an understatement.

abcdefgh
. . . study of the development of letter
ijklmnopqrs
forms touches on the complete cultural activities of man
tuvwxyz

This illustration combines two aspects of Will Carter's work with letterforms, printing and cutting. He designed the typeface *Klang* for the Monotype Corporation (shown below in the 24 point size) and also cut the wood block on which it has been overprinted here.

In the vocation of typesetting, dexterity gained by quiet, judicious and zealous
ABCDEFGHIJKLMNOPQRSTUVWXYZ AB

Light and the mind's eye

ORIGINAL PRINTS AND TEXT BY

J. G. LUBBOCK

Bertram Rota, London

This double-spread title-page, designed for Bertram Rota in 1974, combines Will Carter's drawn Italic with *Palatino* and *Sistina Titling*, both designed by Hermann Zapf. This detail of the Italic shows its actual size.

Lida Lopes Cardozo

Lida was born in Holland and trained in The Hague, where she was a student of Gerrit Noorzij. Now she is firmly Cambridge-based as David Kindersley's partner. She says that she is a letterer first and foremost. 'The techniques for making them must of course be perfected if one is to be a letterer. But a technique can be mastered comparatively quickly. Technically shaping a letter does not necessarily make a beautiful letter; it needs mental development and "feel". All three must work.' In her booklet *Glass and Engraver*, David says of her, 'Glass is only one of the arts that she does superbly.' Actually, Lida says she finds working on glass almost frivolous compared to stone; it takes less time and it is bound to last less time. She feels strongly the advantage of being together in a workshop atmosphere; 'Different people have different strengths, they rub off on to each other. Also different points of view lead to battles, and that keeps you alert.'

This slate house sign, painted off-white, shows Lida's Italic letterforms as she likes to make them, and reflects some of the fun she gets out of them.
It was cut for the Nelsons, of California, who later took a rubbing, reduced it and printed it on their hundred year old press for use as a letterheading.

A deceptively simple, but distinctively designed and engraved bowl.

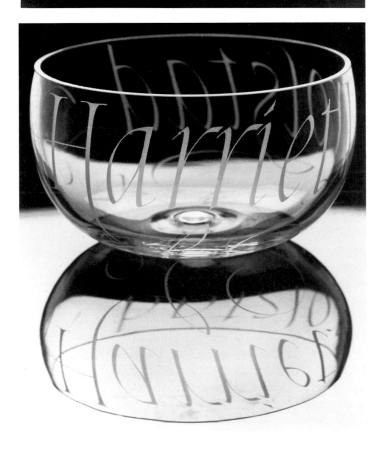

100

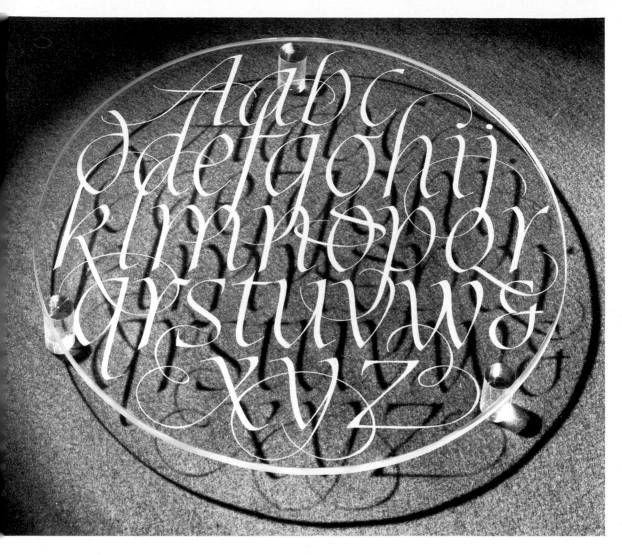

Lida talks about the special attributes of glass as a material. You can start off with relatively cheap glass and work upwards, not forgetting that some glass is best left unadorned. Then, she says, 'The great excitement of glass is its transparency, and to make this work one has to work all round and through the glass.' So get away from the idea of a vignette, a small design or label that only works when seen from one view. Consider and take advantage of the reflections from the engraving. As for the letters, with a drill or diamond stylus (Lida uses a dentist's drill) you can get the finest, most sensitive of lines. But, says Lida, 'However beautiful your letterforms are, it is the spacing that matters above all else. A beautiful letter is ruined spaced badly. A rotten form well spaced is more tolerable.'

This delicate, flourished alphabet, back engraved on a flat roundel, illustrates the points Lida makes about using the special qualities of glass. It is cheap glass and even though it is flat it acquires a three-dimensional quality from the reflections.

HANC BIBLIOTHECAM
DOMVS SANCTI PETRI
ALVMNORVM SOCIORVM AMICORVM MVNIFICENTIA
IN MVSAEO OLIM ARCHAEOLOGICO INSTRVCTAM
SOLLEMNITER INAVGVRAVIT
PETRVS EPISCOPVS ELIENSIS
COLLEGII VISITATOR ET FVNDATORIS SVCCESSOR
DIE VII MENSIS IVLII ANNO SALVTIS MCMLXXXIV
FVNDATIONIS DCC

This inscription, on green slate, is in the library of Peterhouse College, Cambridge and is reproduced by permission of the Master and Fellows of Peterhouse.

Lida feels it important to see the site first: 'You can adapt, then the stone belongs and looks as if it was there from the start.' This Welsh slate memorial (right) is in Canterbury Cathedral.

MEMENTOTE CORAM DEO
WILLELMI GEORGII
VRRY
ET HVIVS ECCLESIAE
METROPOLITICAE ET
VRBIS CANTVARIAE
CHARTOPHYLACIS
APVD OXONIENSES
PRAELECTORIS IN
PALAEOGRAPHIA
AVLAE SANCTI
EDMVNDI
SOCII
1913 1981

MARTIN GLOSTER
SULLIVAN KCVO
1910-1980
Archdeacon of London
1963-1967
Dean of St Paul's
1967-1977

A much loved New Zealander
Speaker & Writer
Friend of the Young

To Lida, Roman capitals are the ultimate discipline: 'Letters that you can discuss, letters that are obviously right or wrong. They give the background from which everything else can flow.' She sees her purpose as a letterer to be the constant refinement of letterforms and feels that discipline is so necessary that you should aim at perfection in one thing. That perfection would then be transferable, in a way, to other work so that no effort is wasted. (This would apply, of course, to other things in life than lettering.)

This inscription on lithographic stone, in St Paul's Cathedral, was painted red and grey using watercolour. This, of course, is not possible if the inscription is out of doors, but it gives a purer colour and allows the stone itself to show through.

FULL SIZE

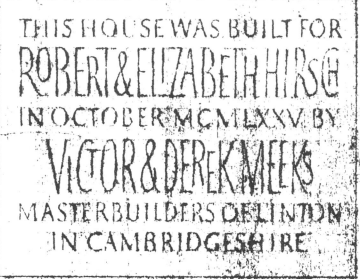

Lida explained that commissions that go out of the workshop are usually joint creations. Here is the first sketch for this inscription, planned by Lida, who felt that she had taken it as far as she could within formal linked letters. Then David took the design in hand and lifted it to another dimension of freedom, linking even the capitals that Lida had let alone.

Notice the difference made merely by the changed forms of the E's within the names, as well as the ampersands.

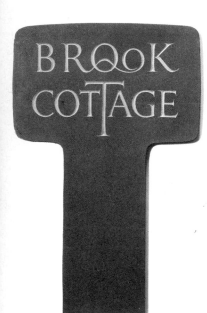

This original, almost informal, house sign engraved on green slate was a real workshop creation. It was designed by David, Bettina did the first cutting and Lida deepened and finished it.

BENJAMIN
GEORGE BURTON
FOX M.C.,T.D.,
born 28th July 1912 · died 6th Nov. 1978
Chaplain H.M. Forces 1939-45
Vicar of St Andrews, Bedford 1946-50
Rector of St James, Montego Bay and
Archdeacon of Cornwall, Jamaica 1950-55
Vicar of St Etheldredas, Fulham 1956-65
Archdeacon of Wisbech
Vicar of Holy Trinity
Haddenham
1965-78
be thou faithful unto death & I will give thee a crown of life

David particularly wanted this inscription to be shown because of the backward slanting Italics. He said that he had long wanted to experiment and use them, but it was not until this layout that they had something real to contribute to the design.

This inscription, designed for a school building that became a museum, vividly evokes a Victorian schoolroom atmosphere. It is cut in Welsh slate and was, once again, a joint workshop job.

ABCDEFGHIJKLM
CONGREGATIONAL
SCHOOLROOM
1·2·3·4·5
6·7·8·9·0
1879 1981
NOPQRSTUVWXYZ

David Kindersley

David Kindersley carries on in the tradition of Eric Gill to whom he was apprenticed. His work covers the whole field of letter forms: stone cutting, alphabet design and typography both using traditional methods and harnessing modern technology. In his workshop he has brought together and trained a whole generation of new craftsmen. He is widely recognised to be Britain's most eminent letterer.

Original painted alphabets by David Kindersley are in museums all over the world, but seeking to make them more widely available he has produced printed series of them silkscreened in different combinations and on different backgrounds. These are both in book form and full sized prints, putting imaginative lettering as an art form back on our walls.
The curtain material designed from these alphabets is shown in detail on the frontispiece.

Remember
BENJAMIN BRITTEN
1913·1976
whose Noye's Fludde·1958
and the three Church Parables
Curlew River·1964
The Burning Fiery Furnace·1966
and The Prodigal Son·1968
were first performed here
by the English Opera
Group

KYRIE ELEISON · KYRIE ELEISON · KYRIE ELEISON · KYRIE ELEISON · KYRIE ELEISON · KYRIE ELEISON

Two contrasting inscriptions.
The memorial to Benjamin
Britten is in Orford parish
church. The quotation below
illustrates, as David says, '. . .
how far you can go away from
classic forms and still the letters
can be recognized'.

**Street name plates
and a system for
letterspacing**

Street name-plates must be instantly readable, often from a moving vehicle and usually at an oblique angle. As a result of a survey which he carried out in the late 1940s David Kindersley was asked by the Ministry of Transport to produce a revised alphabet which could be used whenever new signs were needed.

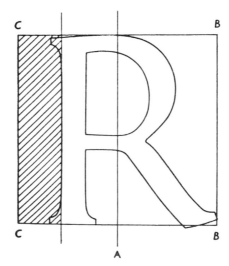

TRUMPINGTON
STREET

In place of the badly spaced sans-serif capitals which were then in general use, he designed a handsome serifed letter and devised a system of letter-spacing which would work for any combination of characters and which unskilled workmen could apply when casting or stamping them in relief. The results show just how well the classic Roman letters can be adapted for everyday use and demonstrate once again the vital importance of space – both inside the letters and around them – in helping legibility.

David Kindersley has defined his spacing system as follows: 'The relation of space to letter should remain constant, in such a way that the optical vertical centre of any letter is also the mathematical vertical centre of the space which the letter occupies. Thus the R, which in most alphabets is the most off-centre mathematically, becomes the key to the spacing throughout the alphabet. The diagram shows the optical vertical coinciding with the mathematical vertical centre of the space at the line A–A. The right side space is limited to the tip of the tail of the R by the line B–B. As explained above, A–B must equal A–C. The shaded part sets the standard for all side spaces to thick vertical strokes. This is the underlying principle of my standard spacing, but there are many modifications that have to be made in order to produce a really even fit.'

While working on this street name alphabet David Kindersley felt that he was 'scratching at the problem of letter spacing'. As a result of his subsequent research he devised the 'Logos' system shown opposite. This system may appear very technical but it depends, in the first instance, on finding the *optical* centre of the letter and is therefore based, like all good letter spacing, on the practised eye of the designer.

108

An introduction to the Logos system of text spacing

Logos has returned to first principles, studying much of the available literature on the eye and perception and researching extensively to see whether the reading eye requires a particular rhythm. First electronics and optical systems were tried using light-wedges that conformed to simple mathematical ideas. More recently a computer and a laser display have been used to simulate more accurately the very wide difference between the receptors in the eye's centre and periphery.

Three important principles have been established:-

1. A reference point is needed within the letter, described as the optical centre. This locates the letter in the centre of its space.

2. Most of the information from which the letter obtains its intrinsic space is derived from the parts near to its periphery.

3. Loosening a given setting should be done by adding a constant to the intrinsic space for each letter.

Once the optical centre (1) and the intrinsic space (2) are correctly determined for each letter, all sequences of letters stand correctly together for any value of the constant added space (3).

It will be quickly understood that the advantages behind the Logos system are truly of very great importance. Firstly, all letters carry their own space information and no reference to a table of letter combinations is necessary. Secondly, the left hand margin of the page is automatically and quite naturally set in optical vertical alignment. Thirdly, there is simple and complete control over the amount of constant that is deemed necessary, aesthetically pleasing or just economical, for letters can now, with the Logos system, be set until they touch.

Epilogue

I N THIS BOOK we have looked at letters that range from the spontaneous attempts of beginners to examples inscribed and drawn by top professionals. As the project grew, the contributors (at all levels) not only donated their work but took part in the discussions that helped to determine the final shape of what I consider to be very much 'our' book.

Some unexpected points emerged in these discussions. It is obvious that beginners can profit from studying superb lettering – but maybe they can learn just as much, though in a different way, from the work of someone nearer their own standard; they can relate to the problems still being solved and develop their own critical faculties at the same time.

Some of the expert letterers, on the other hand, were interested in the beginners' responses to the somewhat unconventional exercises in the first section. Even beginners can produce some original letters that could hold their own with professional work (though they might not be consistently good).

We have tried to keep a balance between preserving spontaneity and stressing the discipline needed to pursue a successful career in lettering, whatever the chosen medium. One message that comes over very clearly is that however perfect or original your lettering may be it can be spoiled by poor spacing.

We have enjoyed sharing our methods and our feelings about our work, and showing both lightheartedly and seriously how lettering can be reproduced and repeated in so many ways for so many uses. We only hope it will extend both your imagination and your skills.

Four of the artists featured in this book are shown at work. Above: Lida Lopes Cardozo, David Kindersley. Below: Gunnlauger, S E Briem, Martin Wenham.

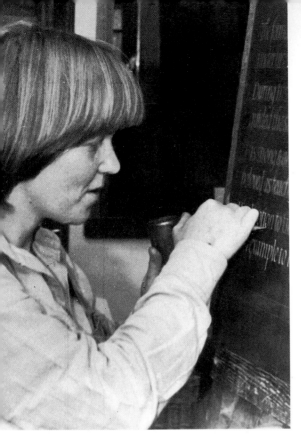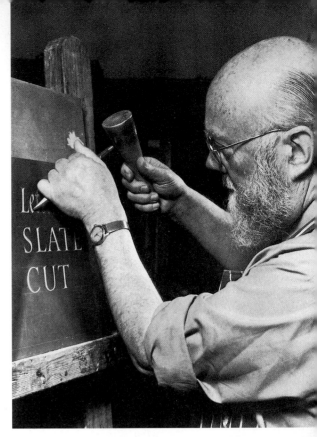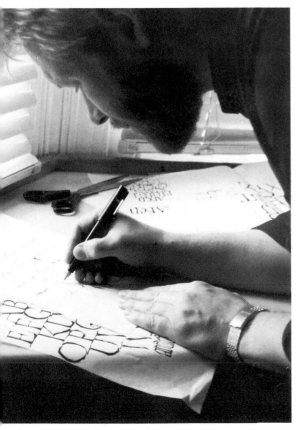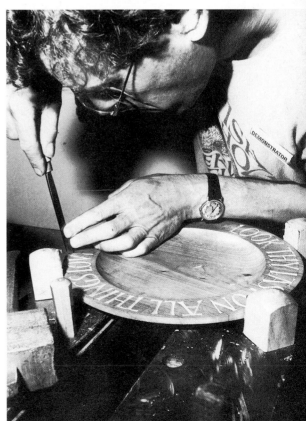

Acknowledgments

This book could not have been written without the help of the contributors. Any acknowledgment is bound to be inadequate and all I can say is a grateful thank-you to every one of them (in alphabetical order): Gunnlaugur S E Briem, Lida Lopez Cardozo, Will Carter, Timothy Donaldson, Bettina Furnée, Gaynor Goffe, Ray Hadlow, Judith Hammer, David Kindersley, Patrick Knowles, Pat Musick, Alec Peever, Tom Perkins, Miriam Stribley, Denys Taipale, Martin Wenham, Fiona Winkler.

I would like to thank my own students who have been such enthusiastic guinea-pigs, and who, along with some of Miriam Stribley's students, have let their work be reproduced. My thanks as always go to my husband John for his encouragement and help in all my work, to Olive Kitchingman who so gallantly deciphered and typed my manuscript and to my friends at Thames and Hudson.

Photographers whose work appears in this book include: John E. Leigh, Frank Mancktelow, Michael Manni, John Myers, Gwillon Owen and Eileen Tweedy.

A carved sundial by Tom Perkins

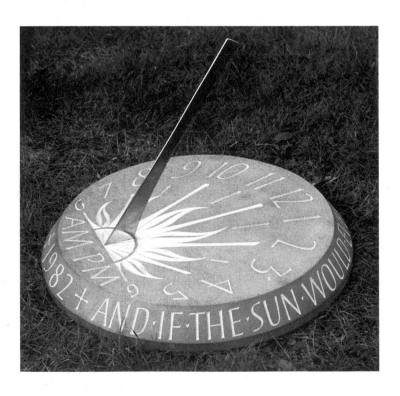